Yilan County
LANYANG MUSEUM
Guidebook

Yilan County
LANYANG MUSEUM
Guidebook

Contents

4 **Stepping into Yilan**

Yilan is a Museum Itself ! 6
Stories of Dark Stones 8
Museum Family 10

14 **Architectural Aesthetics**

Design Concept : the Dialogue between 16
 the Nature and Artificial Landscape
Design Issue 20
 Cuesta : the Art of Geometry
Design Implication : Engaging in a Conversation 24
 with Yilan
Construction Challenges 34

40 **Birth of the Lanyang Museum**

Embracing the Land 42
Reserving the Variety in Nature 44
Taking Nature at Heart, 46
 Delivering a Human Side

50 **Presence in Lanyang**

The Birth of Yilan 52

56 **Mountain –
 Motherland for Yilan**

Natural Treasures 58
Routes into Yilan 68

72 Plain –
The Hometown to Rain

Abundant Water Resources	74
Ethnic Groups and Cultivation	80
Chronicle of Customs	88
Water Transport That Flourished Lanyang	94
Water and Life	100

106 Ocean –
Life by the Ocean

Artistic Image of the Ocean	108
Secret Under the Ocean	112
Various Coastlines	116
The Kavalan Tribe's Affinity with Water	120
Water Birds' Paradise	124
Fish Swarms	128

136 Impressions of Lanyang

Touching Moments	138

142 Behind the Scenes

Passion Paves Way for the Lanyang Museum	144
The Emblem	148
Major Events	150
Visitation Guide	154
Information	158

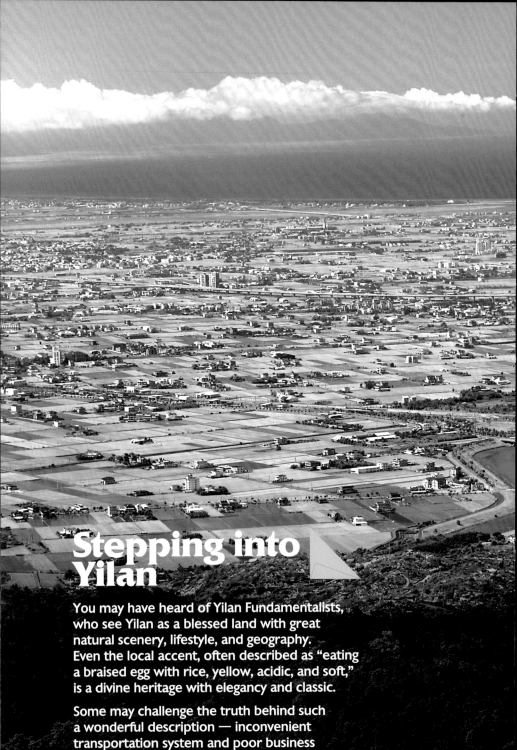

Stepping into Yilan

You may have heard of Yilan Fundamentalists, who see Yilan as a blessed land with great natural scenery, lifestyle, and geography. Even the local accent, often described as "eating a braised egg with rice, yellow, acidic, and soft," is a divine heritage with elegancy and classic.

Some may challenge the truth behind such a wonderful description — inconvenient transportation system and poor business

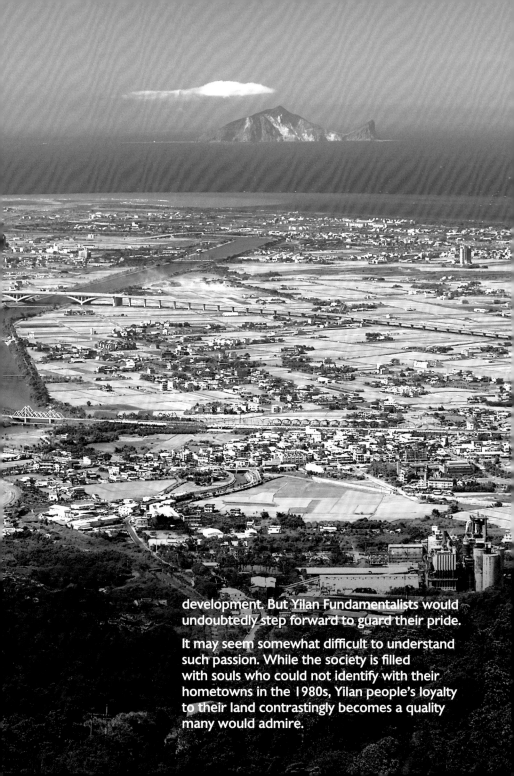

development. But Yilan Fundamentalists would undoubtedly step forward to guard their pride.

It may seem somewhat difficult to understand such passion. While the society is filled with souls who could not identify with their hometowns in the 1980s, Yilan people's loyalty to their land contrastingly becomes a quality many would admire.

Yilan is a Museum Itself !

I n 1990, a group of fervent Yilan people decided to build a museum to showcase the region's nature and culture.

Limited museums existed back then. To some folks, all museums were equivalent to the National Palace Museum, which was no more than a large building filled with treasures. As for the way to construct such a large building, it was another challenge.

That drove the Yilan County Government to invite Lu Li-cheng, a Yilan native and also a township expert from the National Museum of Prehistory, back home to start a museum.

Yilan, a place filled with beauty of ecology and culture, is a large museum itself worth of visitors' staying and discovery.

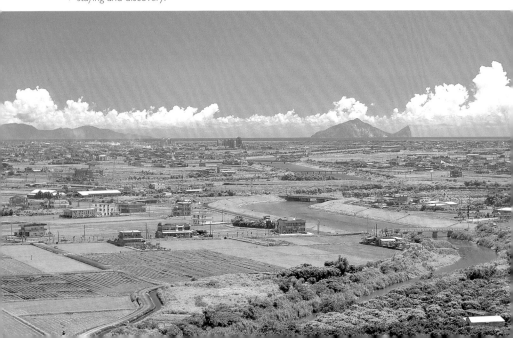

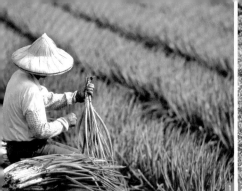
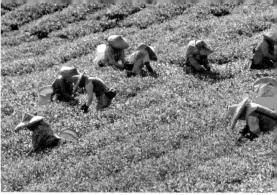

Lu understood Yilan was indeed a poor county. In terms of the architecture, the collection and structure of the organization, it would be difficult to make the Lanyang Museum outstanding in any way.

Nevertheless, Yilan's best asset lied in its ecology, historical sites, cultural activities, and devoted locals. If these characteristics could be organized and exhibited properly for further learning activities that help locals and visitors understand the area's heritage, it would be possible to make a lively museum with comprehensive Yilan coverage.

In addition, if the founding of the Lanyang Museum can provide an example for the region, Lu confidently felt that Yilan's museum circle would become the top cultural role model for the rest of the nation. The principle — Yilan is a museum itself — jumped out to be the main principle for Lanyang Museum's establishment.

Following this thought, the Lanyang Museum is given an important role — a window to Yilan's nature and culture. By preserving the local nature and humanity, as well as integrating the research resources, the museum aims to become a dynamic education venue. 🌸

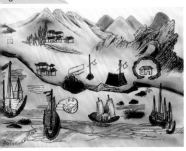

You may see Wushi Port reached its heyday with numerous ships packing its waters in the Qing Dynasty's paint "Spring Sail in the Wushi Port."

Stories of Dark Stones

The Wushi Port, also known as the "dark stone port," was named from the three large dark stones in the region. Once the most important port in Yilan in the Qing Dynasty, the Wushi Port reached its heyday with numerous ships packing its waters.

In 1826, the Wushi Port was officially appointed the "Zheng Kou" (the official entry) by the Qing imperial court, meaning that all goods for trade would go through this port. Back then, goods would first enter the river from the Wushi Port and then head to the Touwei Port before reaching Yilan City or the Yuanshan Lake. Its geographical significance controlled the economy of the Yilan area.

From the end of the 19^{th} century, the Wushi Port has gradually lost its function, as floods brought a substantial of sedimentary sands to block the river course. With the completion of the railway system during the Japanese Colonial Period, the rising inland transportation eventually took the place of water transportation, severely impacting the commerce of Toucheng.

After a hundred of years, the current Wushi Port is no more than plain water and land. The port is leased for fishery and water chestnut farms, but the land formed by the river deposits has low agricultural value due to its high concentration of salt. However, salt-water guava and peanut from this soil are outstanding.

The Wushi Port was revitalized in 1991, as the Fisheries Agency under Council of Agriculture built a

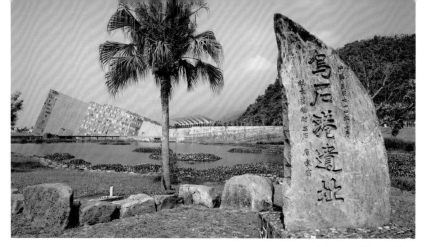

new ocean fishery port over the old Wushi Port, with a fishery building constructed on the port zone. Then, leisure fish boats were introduced to provide the whale watch services and excursions to the Guishan Island, which successfully changed the value of the Wushi Port.

Finally, at the end of the 20th century, Yilan people's outcry for a museum was heard. In 1999, the Executive Yuan passed the proposal for building the Lanyang Museum next to the old Wushi Port site. The location is undoubtedly a very appropriate choice, as the port has always been a gate into Yilan, which would also successfully make it a window into Yilan's culture.

Besides, the location made the museum face the Guishan Island, the landmark for Yilan. The dark stones in the site reflect the history, culture, and the geographical feature of the area, while the site itself becomes a permanent ecology of the wetland. The 10.9 hectare site may function as a ground of recreation and activities for the community, making the museum coexist with its environment even more meaningful. 🌺

Museum Family

In December 1992, the Yilan County Government established the museum's Preparatory Planning Committee and officially agreed on the name "Lanyang Museum." From 1994, the government commissioned Dr. Chang Yui-tan at the National Museum of Natural Science and the National Taiwan University Building and Planning Research Foundation to carry out the planning project for the museum. After years of discussions, the museum outline was gradually formulated.

When the planning process was almost completed, the Yilan County Government sought aids from upper administrative organizations. To avoid disruption of the construction process, a Yilan County Museum Group Committee was established in 1997 to facilitate the preparatory work for the Lanyang Museum.

In order to expand the museum network throughout the county, the preparatory team established a "Yilan County Museum Family" to conduct searches on county members who have museum resources. The family members cover comprehensive groups including the Atayal, the Kavalan, the Hakka, the Taiwanese,

宜蘭縣博物館家族協會
I-LAN MUSEUMS ASSOCIATION

宜蘭設治紀念館・甲子蘭酒文物館・台灣戲劇館・仰山文教基金會九芎埕人文空間・宜蘭縣史館・慈林基金會・台灣民主運動館/慈林紀念館・二結庄生活文化館・學進國小校園采風館・宜蘭縣自然史教育館・孝威國小校園博物館・北成庄荷花形象館・白米木屐村・珍珠社區博物館・珊瑚法界藝術館・碧涵軒帝雉生態館・南安國中漁史文物室・陳忠藏美術館・無尾港生態社區・冬山風箏館・無尾港文教促進會・養蜂人家蜂采館・呂美麗精雕藝術館・樹木教育農場・蘭陽博物館・北關螃蟹博物館・河東堂獅子博物館・橘之鄉蜜餞形象館・宜蘭設治紀念館・甲子蘭酒文物館・台灣戲劇館・仰山文教基金會九芎埕人文空間・宜蘭縣史館・慈林基金會・台灣民主運動館/慈林紀念館・二結庄生活文化館・學進國小校園采風館・宜蘭縣自然史教育館・孝威國小校園博物館・北成庄荷花形象館・白米木屐村・珍珠社區博物館・珊瑚法界藝術館・碧涵軒帝雉生態館・南安國中漁史文物室・陳忠藏美術館・無尾港生態社區・冬山風箏館・無尾港文教促進會・養蜂人家蜂采館・呂美麗精雕藝術館・樹木教育農場・蘭陽博物館・北關螃蟹博物館・河東堂獅子博物館・橘之鄉蜜餞形象館・宜蘭設治紀念館・甲子蘭酒文物館・

Memorial Hall of Founding
of Yilan Administration

and migrants from Mainland China, as well as various geographical locations in Yilan County, and industries such as farming, forestry, fishery, and husbandry.

The Yilan County Museum Family is a group established under free will. Each member shares museum resources, mutual manpower support, identification system, communication system (pamphlets, guide information, visitor passport),

1. Taiwan Theater Museum
2. Institute of Yilan County History

websites, museum resource development strategies, integrative education planning and promotional activities.

The purpose of the Lanyang Museum and the Yilan County Museum Family advancing at the same pace is to activate a greater museum movement for Yilan County. Such flexible structures would enable the Lanyang Museum to be lively with ongoing resources. 🌿

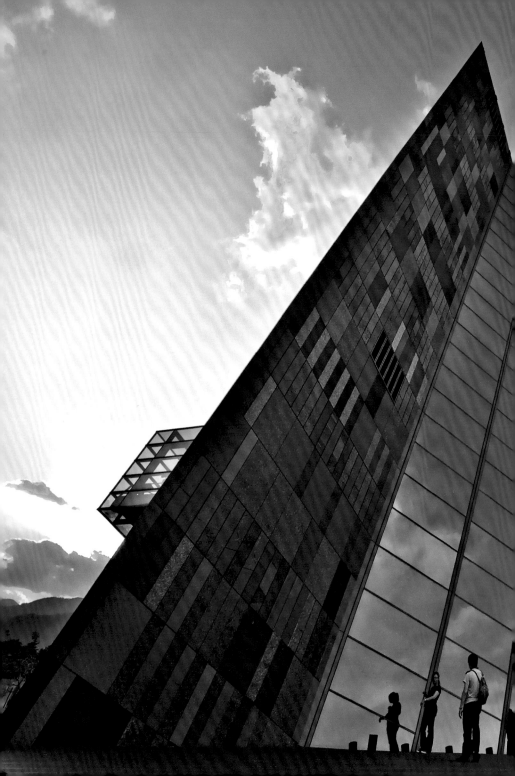

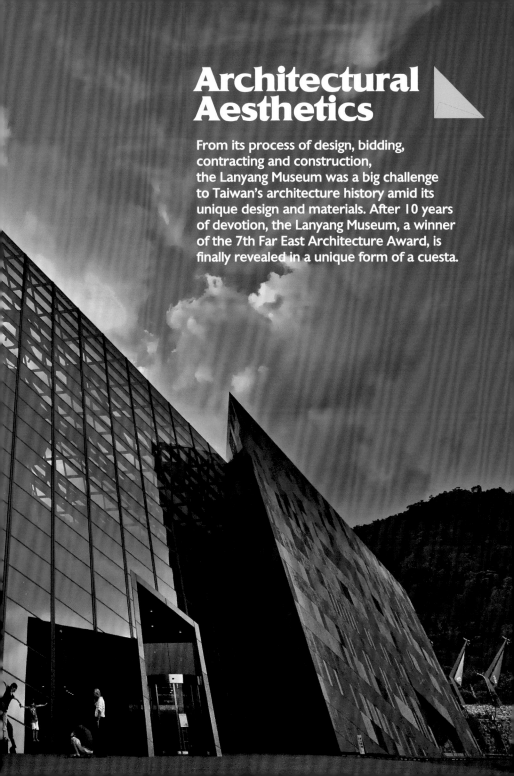

Architectural Aesthetics

From its process of design, bidding, contracting and construction, the Lanyang Museum was a big challenge to Taiwan's architecture history amid its unique design and materials. After 10 years of devotion, the Lanyang Museum, a winner of the 7th Far East Architecture Award, is finally revealed in a unique form of a cuesta.

Design Concept : the Dialogue between the Nature and Artificial Landscape

In 1994, the Yilan County Government commissioned the National Museum of Natural Science to plan the program for the Lanyang Museum by formulating its outlines and perspectives including the goals, site analysis, the structure of content and the initial layout. The architecture programming was also in process of design concept and planning.

In 1996, the county government further commissioned the National Museum of Natural Science and the Building and Planning Research Foundation, National Taiwan University to process "the project of the tangible and intangible detail planning and design of the Lanyang Museum" that included seven sub-plans with a perspective to connect the overall planning and schematic design in architecture. The seven sub-plans were as follows:

1. The Operation and Management;

2. The Collection Research and Development;

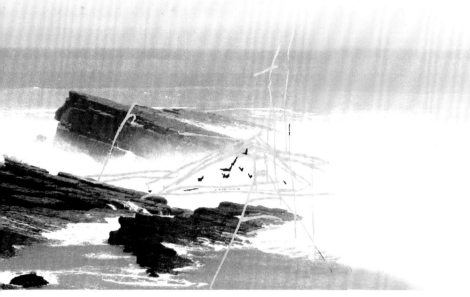

Cuesta: tides and the gigantic cuesta stone in Beiguan inspired the architect to depict the embryo of Lanyang Museum.

3. The Implementation Workshop;

4. The Education and Planning;

5. The Exhibition Details in Planning and Design;

6. The Detailed Planning in Landscape Building for Public Construction;

7. The Museum Research and Promotion;

In 2000, Artech Architects Inc was selected among nine companies during the public design competition for the museum's architectural planning and design, officially leading the Lanyang Museum to the further stage. The design goal was to preserve the environment by minimizing the impact on the wetland, while the object for the architectural planning was to adopt a simple triangle that symbolized the landscape of Yilan. As for the landscape front, the design mainly focused on wetland preservation and maintenance, creating a compatible environment between the natural views and artificial landscapes.

From the stage of design to construction, Lanyang Museum always adhered to the important principles including geophilic, ecosystem, function, historic conservation, as well as minimal impact on the wetland.

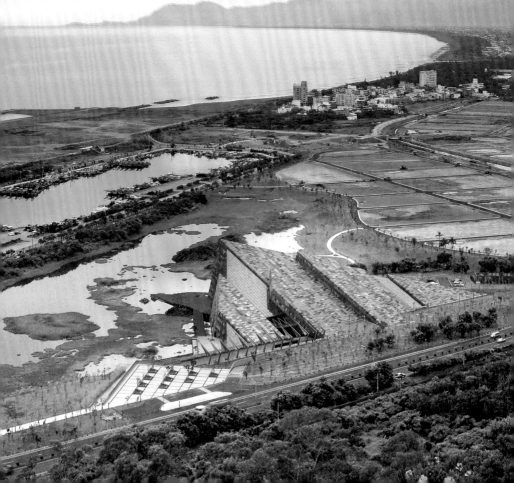

Design Principles and Recommendations

Led by Liu Koh-chiang (the CEO of the Building and Planning Research Foundation), the team of National Taiwan University in charge of the detailed planning in landscape building for public construction drafted basic design proposals, follow-up process and various plans for different stages. They also worked with the architecture team to determine the principles and recommendations:

1. The site-planning should preserve the old Wushi Port wetland, while incorporating the dark stones, wetland and the Guishan Island as part of the exhibition.

2. The architecture mass should present a sense of local style, blending into the surrounding sceneries.

3. The exhibition space should be a long-span space without columns.

4. In terms of circulation, the archives and administrative areas need to be separated from the routes for visits or activities.

5. The public service area should include restaurants, shops and classrooms, located in a space free of admission charge.

6. As for the space allocation, for reflecting the sense of settlements in northern Toucheng and presenting the environmental characteristics of friendliness and simplicity in Yilan, it is recommended that the architecture mass should be spread over the hill, with the corridors connecting all the small masses.

The principles mentioned above were thoroughly implemented in the architecture, except scattering the architecture over the hill. The architect recommended the site plan to be concentrated on minimizing the impact on the wetland and increasing the spatial utility, which was agreed and accepted by the committee. At last, this was the only part different from the original suggestion.

From the stage of design to construction, the Lanyang Museum always adhered to the important principles including geophilic, ecosystem, function, historic conservation, as well as minimal impact on the wetland. When the sun shines on the cuesta-shaped building, one can feel a strength flourished by this land. 🌿

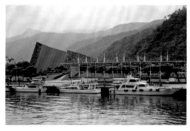

Based in the Wushi Port area, Lanyang Museum inherits the fluctuation of history and culture and takes the responsibility of safeguarding the environment in Yilan.

Design Issue
Cuesta : the Art of
Geometry

t is the Lanyang Museum's main concept that has every visitor experience the idea "the site is the museum."

Incorporating the unique cuesta landform seen on the northeastern coast of Taiwan, the museum's architecture design is based on patterns existed in the natural environment. The observation of nature

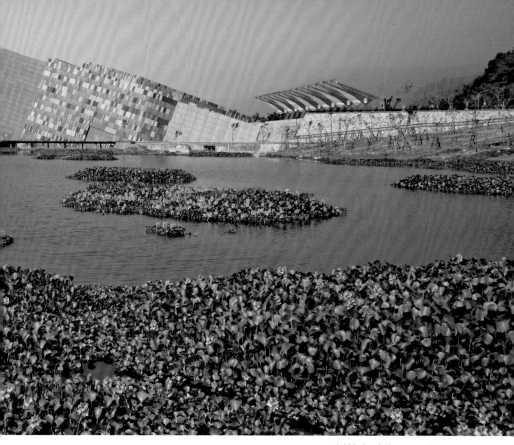

Wetland: the operation of the museum is to compensate the wetland and reserve the ecological system.

is artistically transformed into the architecture appearance resembling a gigantic cuesta stone in Beiguan. The axis of the building points to the Guishan Island, the symbol of Yilan. Besides, the museum is built on the old site of the Wushi Port, reminiscent of the ancient days and the identities in Lanyang.

To implement the idea of "co-existence with the environment" and "blending with the nature," the layout of the mass mostly concentrates on reserving as much wetland as possible. A walk path is designed surround the wetland to provide more

Landscape Design

Retro boat-shaped wooden platform: located along the western side of the parking lot, this rest area offers visitors the view of the old river course and the deepest waters of the wetland. You can marvel at the most extraordinary museum building reflection on the water here.

Getting close to the nature on the wooden platform: the northern part of the building and the surrounding waterfront areas are paved with pebbles, one of the constant species in Yilan, with an elevated wooden pass to be built for lowering environmental impact on the wetland. You can amble around this walk path to admire the sceneries and ecology. The platforms located in the different areas with different heights can also be used for various performances.

The Beiguan Tide at the entrance plaza: at the entrance of the museum plaza lie several cone-shaped plant fixtures that correspond to the cuesta shape of Lanyang Museum. When looking down at the lake from the eastern side, the view is almost comparable to the ocean view seen when standing at the stones in Beiguan.

Noise blocking by original forests at the northeastern side: the wax apple trees were mostly kept during the construction, while plants suitable for low altitude areas in the Northeastern Taiwan were grown, including the red nanmu, the ardisia sieboldii miq., the sapotaceae, and the schefflera trees. In the future, these trees can help maintain the landscape and block the noise from the Provincial Highway No. 2.

Old tomb telling the history: the southern part of the building is an elegant tomb, a family cemetery belonging to the Mr. Lin Cai-ten, a former Yilan County governor. The museum left this tomb undisturbed as it is a part of the area's history. Plants were grown around it to maintain the quietness and reduce the noise coming from the new communities of the south.

Admiring the scenery of the ocean front heath: the southern side of the lake lies a mild slope and a forest. The water plants are reserved while large amount of forests are grown in the south. Visitors can enjoy bird watching along the pathway.

Dark stones overlooking the Guishan Island: a wooden walkway is specifically designed between two large stones and extended into the middle of the lake. You can follow the walkway to face the Guishan Island with a closer view of the dark stone textures and ecology.

The cone-shaped plant fixtures on the Beiguan Tide at the entrance plaza correspond to the cuesta shape of the architecture.

thorough experience to visitors. The original wax apple forest and bamboo forest were reserved for lowering the impact on the nature, while a diverse ecology environment that comprises woods, meadow, and wetland were created for offering a functional area for ecology observation, recreation, and education purposes.

The sustainability of design is also the main issue in the museum. For instance, the on-site wetland also functions as a rain water reservoir, which can be used in case of fire. The light steel structure system was selected for the design, while durable and recyclable materials were used for the wall. To ensure proper lighting, safety, and energy saving, Double Low-E glasses — a laminated compound glass with low radiation and emissivity which could effectively block most of the UV light and infrared light without filtering out the sunshine or compromising the view — were adopted for the curtain wall.

The museum's design proposal is proudly qualified as a candidate for Green Building by successfully meeting the nine criteria in the Green Building Code, including quality improvements in biodiversity, greenery, on-site water retention, energy efficiency, Carbon dioxide-emission reduction, waste reduction, indoor environment, water resources, and sewage and garbage. 🌺

The supervision from the inspection unit and county government made sure the quality of Lanyang Museum's project meet the national standard.

Design Implication : Engaging in a Conversation with Yilan

To be built on historical remains, the Lanyang Museum is designed according to the texture of nature, combining the humanity with the history

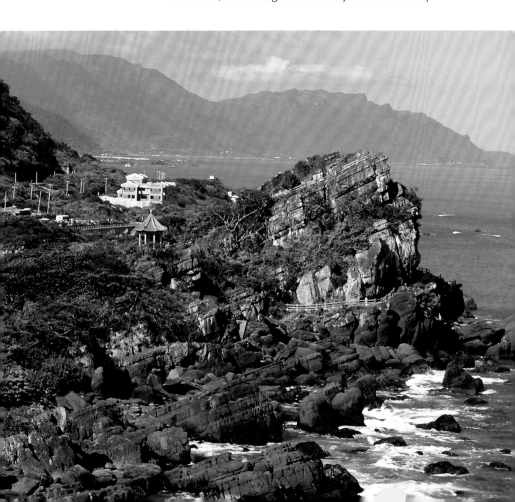

to inspire visitors' interest in further exploring the natural and cultural resources in person.

The Unique Shape: Cuesta

The northern coast of Yilan is a typical erosive one, containing wave-cut platforms and cuesta landforms. The Beiguan Tide Park is the best example of a cuesta at the north of the Lanyang Museum.

The cuesta in the Beiguan Tide Park is tilted strata composed of various stones, making a special scene and becoming a designing characteristic for Lanyang Museum's architecture.

A cuesta refers to a mountain with a mild slope on one side and a steep one on the other. It is formed when the sedimentary rock strata alternating with sand stones and shale stones are pushed and raised during orogeny. Since the tilted strata would become eroded by the sea, the bottom layer is softer with eroded dents, while the upper layer is still tough and unaffected. Eventually, the soft rock gets hollowed out with even bigger dent, and the hard rock on top collapses with the loss of support, which further forms an incongruent slope.

Because the Pacific Plate was pushed in from the southeastern side, Yilan's rock strata would skew toward the northwestern side. For bringing rapport between the Lanyang Museum and the surroundings, the building was given a cuesta-like geometrical shape, with the gentle slope forming a 20 degree angle on the ground, and a 70 degree angle between a more inclined slope and the ground.

Rock Patterns

The patterns of the outer wall is arranged to resemble that of a cuesta by layers of stone and aluminum boards. When it rains, the stone boards that become darker for absorbing water, with

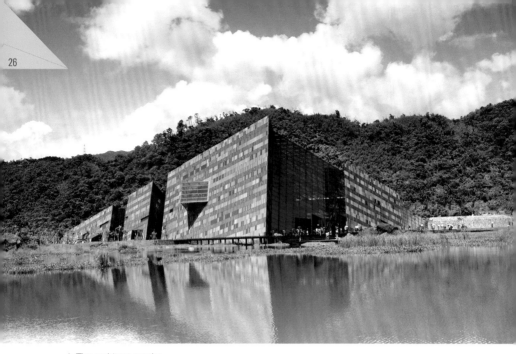

The architect cut the building into 10 parts and rearranged the split parts horizontally and vertically, signifying to the weathered reef gaps on the appearance.

the waterproof aluminum ones presenting the other outlook. The diverse materials and textures bring rich appearances and special patterns by the erosion on a cuesta.

Symbols of Cuesta Gaps

The architect created a vertical cut on the cuesta-shaped massing, and then rearranged the split parts horizontally and vertically. Such arrangement applies to the weathered reef gaps on the appearance, while forming and zoning the interior areas.

The four massing compositions created for spatial rearrangement are covered by glass curtain walls, which not only form the interest of space by a spatial division via diverse material, but also provide each area with lighting. The

overall presentation brings a visual see-through when overlooking the Wushi Port, effortlessly incorporating the surrounding into the interior, creating a conversation between the architecture and the environment.

Interwoven Space Masses

The massing compositions split the interior into 4 areas from the north to the south, including outsourced management, public service, exhibition, and collection and administration respectively, together making a functional zone.

The two masses beginning from the north are areas with outsourced management, including a café and a conference hall. The third mass, the largest one covered with glass, is the public service area and the lobby, where visitors may enter from either eastern or western side. There are service and ticketing desks, as well as computers for tour information. An introductory video of the museum is located on the second floor. The fourth and the fifth masses are the exhibition area, containing the introductory and main display hall, restrooms, and other related facilities. The sixth to the last mass

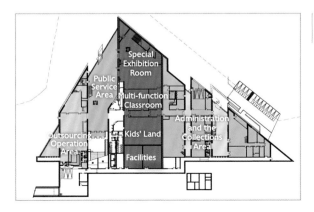

The space planning ichnography for the first floor

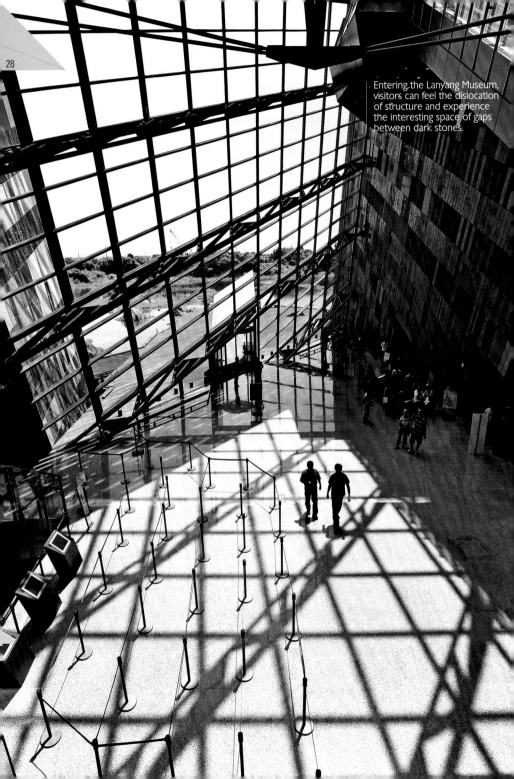

Entering the Lanyang Museum, visitors can feel the dislocation of structure and experience the interesting space of gaps between dark stones.

are collection and administration divided into the work area, the collection, and the office. Visitors are not permitted into the area. At the western side of the building is a long chamber and machinery room, where air conditioning system and generators are located.

A Melodic Appearance: *Four Seasons*

Looking downward from the heights, the Lanyang field is paved with squares of different sizes in various color tones that would change according to season and time. The architect took inspiration from *Four Seasons* by Antonio Vivaldi and transforms the notes into a visual melody on the outer wall, where he exploited different stone materials and colors to deliver the sceneries of each season on the Lanyang ground.

The architect presented the musical movement of *Four Seasons* in a specific order: starting at the bottom left-hand corner of the roof, stretching from bottom to top, left to right, and then outdoor to indoor.

Musical Notes: 12 Stone Textures

To present the 12 notes in an octave, the architect chose four stone materials: Indian Black, Verde Lava, Caledonia, and Rustenburg, each executed with three types of surface finishing "Water-jet," "Honed," and "Antique," to create 12 textures and represent eight whole tones and four half tones which comprise a full octave.

For the rests, he formed splits on the surface of each stone material, with all sounds of the *Four Seasons* to be completed after transferring to the exterior.

The outer walls composed by different stone boards look like the Lanyang Plain overlooked from the sky.

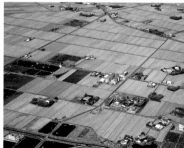

Tempo: 3 Stone Lengths

To demonstrate tempos, stone materials are cut into the measurements of 30 centimeters, 60 centimeters and 90 centimeters, representing the 16th note, the 8th note, and the quarter note respectively. All rests are designed to be 30 centimeters regardless of the duration.

100 Types of Cast Aluminum Boards

Each music movement is divided by the aluminum board trims. There are five sets of aluminum boards finished with a rough texture to imitate stones washed by the water. Each texture is made into five styles, with each style spray-painted in one of the four color shades. Finally, there are 100 different cast aluminum boards (5x5x4) used as dividers for each movement.

Four Seasons: The Outer Wall's Stone Materials vs. Notes

12 Musical Notes

Indian Black (Water-jet) c	Verde Lava (Water-jet) a	Caledonia (Water-jet) g	Rustenburg (Water-jet) d
Indian Black (Honed) d+	Verde Lava (Honed) g+	Caledonia (Honed) a+	Rustenburg (Honed) c+
Indian Black (Antique) f	Verde Lava (Antique) e	Caledonia (Antique) b	Rustenburg (Antique) f+

4 Rests

Indian Black (Split) #1	Verde Lava (Split) #2	Caledonia (Split) #3	Rustenburg (Split) #4

Visiting Route Reflecting the Landscape of Yilan

Be it early residents or visitors of the modern day, anyone who enters the Lanyang Plain via mountains would share the same spatial experience when looking over the waters, the plain and the Guishan Island. The architect designed the museum's visiting circuit by the inspiration from this fact.

First of all, you can get off the car at the entrance by Provincial Highway No. 2 and pass by the entrance of Beiguan Tides where the cuesta-shaped tree holes corresponding to the main structure. The different-sized stones paved on the ground have gaps to allow weeds growth like the mosses grown on dark stones.

Keeping moving forward, you can see 14 light poles hang with flags parallel to the building roof,

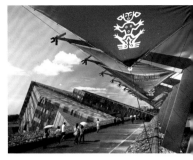

The sails, riggings and flags symbolizing the image of Wushi Port fly through the wind, welcoming the museum's visitors.

Polishment / Stones	Water-jet	Honed	Antique	Split
Indian Black				
Verde Lava				
Caledonia				
Rustenburg				

reflecting the past glory of the Wushi Port.

Following the path down the steps slowly and turning left to the museum entrance, your body and vision would both descend as if approaching a wetland or entering into a gap between giant rocks. Then, you will see the green landscape lying at a far corner by entering in the lobby.

If you walk forth and look up, your vision would widen instantly by looking up to the ceiling structures suggesting the sails that pack the port. Further down, you will see dark stones lying and remark the view of boarding a boat in the ancient times. Then you may see a steel bridge hanging high above with mountains close in hand by following the steps up. It is the Lanyang Plain's geographical relation that creates the kind of experience for visitors to be that close to both the mountain and water.

By taking a left turn to enter the exhibition hall, you would see the rain-like lighting implying the idea of "the Lanyang Plain nourished by the rain" and the beginning of exhibition. Then go up on the escalator and find the scenery of "dark stones - wetland - inner bank-harbor - outer bank-seaside - the Pacific Ocean - the Guishan Island," the land dividing the water into areas of different sizes. Further, you should reach the platform on the fourth floor to overlook the Guishan Island, the emotional tie for all people in Yilan.

Then, turn right to pass the shear wall and enter the highest level of the museum, the Mountains Level, and look down beside the elevator to see the lighting installation of Yilan's solid map. By walking to the right along the descending ceiling and reaching the handle, you would find the deck does not connect to the roof, while hanging over the third floor — the Plains and the second floor — the Ocean by looking downward from the roof.

You can also look up here to see the "A Miracle Up Above," a water-themed film that plays on the skewed ceiling across over three stories.

Finally, immerse yourself in the geographical and cultural beauty in the Lanyang Museum's column-free space, where the mountain, plain, and ocean coexist to bring a visual experience just like looking down from the summit of a mountain located in Yilan. 🌾

Look down beside the elevator, the lighting installation of Yilan's map is shining.

The deck does not connect to the roof, creating a column-free space that provides a good view.

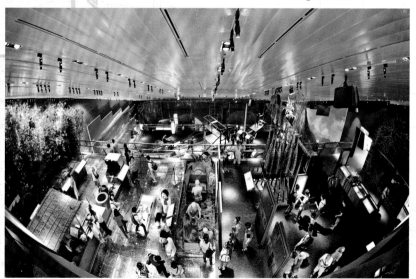

Construction Challenges

The construction process of the Lanyang Museum was filled with challenges, such as the harsh weather, engineers operating in the sky, the construction quality, structural safety and so on. A three-stage quality assurance process for construction was in place to ensure that the subcontractors follow the correct measurements and construction steps. The inspection unit also worked with county officials to make sure

that steel part sizes and related documents match. Other random tests, both chemically and physically, were conducted to materials for confirming that everything meets the national standard.

These strict procedures aimed to control the construction quality; hence, from the basic infrastructure to the completion, the architecture took almost 1,500 calendar days to be finished.

Challenges of Building the Architecture of Unique Shape: Cuesta

To ensure the architecture meet the exhibition's demand on long spans, architectural methods such as splits and displacements were applied to dividing the whole building into 10 masses in different sizes: six solid masses made by reinforced concrete and four void masses made by curtain wall.

No columns exist inside the building. The building is designed to use shear walls as columns and steel trusses as beams. 10 shear walls were built, ranging from 25 meters to 71 meters, with the height up to 31.5 meters, and thickness between 50 and 90 centimeters. Since the north side and the south side of the building are not parallel, a close-structured mass must be composed with the construction of six objects, such as shear wall, external wall, roof, retaining wall and the floor.

The glass boxes — the void masses, were placed between concrete masses. Each steel truss structure, comprised of three round steel columns, was arranged parallel to the roof in equal distances, connecting the two shear walls. Then the fishnet-like

Architects divide the whole building into 10 masses in different sizes. The construction of these masses was very difficult, though it looked easy.

Terminology

- Long Span: architectural structures over 30 meters of length, generally used in public spaces, such as exhibition halls, gymnasiums, or airports.

- Steel Truss: different from the steel, a steel truss is made by thinner steel rods constructed by principles of structural dynamics. They form something similar to high strength steel to support the building as beams and columns. It is a popular structure for modern architecture because great strength can be created with less steel. However, it still cannot wholly replace high strength steel.

- Low-E Glasses: known as Low-emission duo-layer glasses, Low-E glasses contain three layers of 6mm thick glass and 1 layer of 12mm vacuum, which could effectively block most of the UV light and infrared light without filtering out the sunshine or compromising the view. Its ability to block heat helps to reduce the usage of air conditioning, making it a mainstream product for curtain wall architecture.

- Steel Deck: a type of steel boards. The wave design on the surface makes it sturdier in hardness and capacity than usual steel boards.

- Leveling: when a building's concrete work is completed, the ground surface may be uneven. Construction team usually uses infrared light to ensure its finished height so that the stone materials would not lay down in uneven height.

Engineers often operate the work in the height of 30 meters as well as the harsh weather of northeast monsoon.

steel frame structure was placed over before the Low-E glasses were installed.

The Construction of Floor and Roof

Aside from the flooring at first floor, the remaining floors and the roof have steel trusses comprised of three round steel tubes as the main structure. The three steel tubes were first assembled on the ground to connect with the steel rods on shearing walls. For a longer spatial span, heavy scaffolds were used to support the structures to avoid sinking and bending.

Due to the rainy weather, the roof and the external walls are applied with waterproof

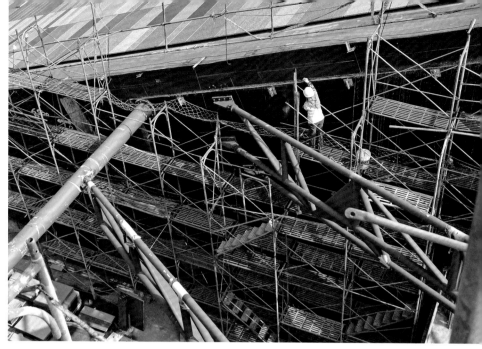

The steel truss makes the crossbeam, with a lattice sub-structure and glass curtain wall to compose the architecture's void masses.

substances. To avoid damage of the waterproof layer, a 3-centimeter long concrete wall was built to prevent construction errors.

When building the roof with 20 degrees of deviation, wooden rods were used to avoid loss of concrete, followed by further layers of work. As soon as the concrete hardens, it was flattened right away to reduce occurrence of gap formation, which may lead to leakage.

For concerns over the temperature changes, structural safety, and construction works, the 70 degree slanting wall had to be built in sections of 3.6 meters and completed in 2 steps, with a 21-day interval in between. The process involved accurate dynamics calculation. The structural boards had to be arched with constant adjustment to avoid architectural errors.

11 Construction Steps

1. The construction team submitted material and draft blueprints, and examined the measurements and construction steps.

2. Each glass curtain wall's (mass) main structure was steel trusses made of three steel rods plus a welded slanting rod.

3. Three layers of spray paint for each fireproof paint and surface paint.

4. The curtain walls were delivered to the construction site for further welding work.

5. All the parts were installed by a crane according to construction steps.

6. After cleaning the borehole, the wall parts were fixed on the shearing wall by chemical bolts.

7. Special-designed steel boards were welded to the vertical components.

8. The horizontal components were tuned by levels before being fixed.

9. Low-E glasses were installed piece by piece.

10. Boards were installed between glasses. Gaps were then filled by silicon before cleaning.

11. Leak tests were conducted by repeatedly spraying water. The curtain wall was completed.

The on-going construction project for outer wall in May 2009

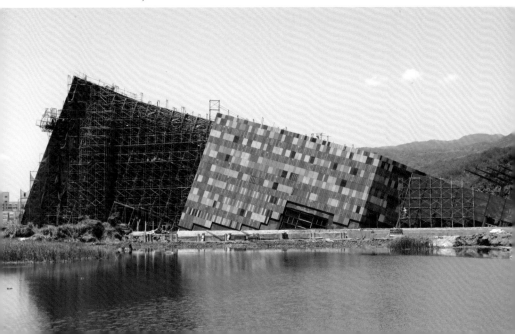

Nanfeng No.1

The wooden fishing boat "Nanfeng No.1" is the largest exhibit in the museum. Before the second floor's ceiling construction was finished, the boat had to be installed with the help of a large crane. The boat was placed inside an iron container during the construction to avoid damage from other construction works. It was not unveiled until the opening of the museum in May, 2010, a three-year long waiting.

20,000 Stone and Aluminum Boards

An architectural symphony of *Four Seasons*, the design of the museum's external walls is collaged by over 20,000 boards, including 16 different stone textures and 100 types of cast aluminum boards.

Carefully selected stone materials were first processed and washed into different textures, and then cut into various length and thickness under the same width. The making of aluminum boards began with wooden incised molds, followed by sand casting. When two sand castings for front and back were completed, they were combined to form a prototype. Fine sand was added to fill any gaps in between. Then aluminum was liquefied to fill the prototype. Lastly, steps of acid wash and blow drying, three procedures of spraying, painting and polishing, and baking enamel were applied to complete the making of an aluminum board.

Once the main materials were prepared, the team began leveling with piano wires and produced the angle bars. When everything was made ready, the stone construction began from bottom to up, with each board installed to the designated place. 🦋

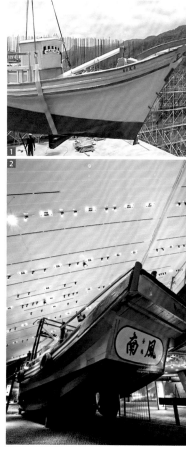

1. The "Nanfeng No.1" was moved to the exhibition hall by crane.

2. The wooden fishing boat "Nanfeng No.1" is the largest exhibit in the museum.

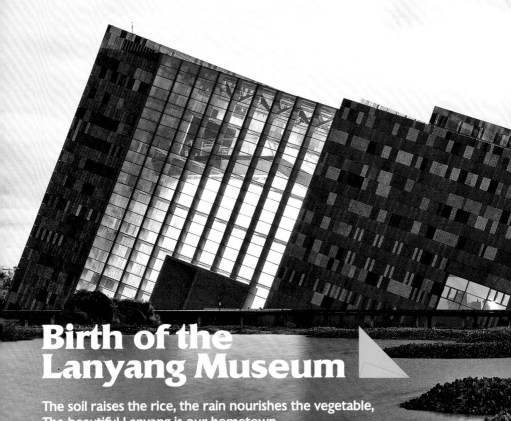

Birth of the Lanyang Museum

The soil raises the rice, the rain nourishes the vegetable,
The beautiful Lanyang is our hometown.
Wu Sha opened up the green plain, the turtle looks far away to the sun of life.
The sunshine beams on the shoulders, the sweat drips to the ground.
From Toucheng to Su'ao, from Xue Mountain to the ocean.
The land of hope, the hardworking people.
The rain nourishes the vegetable, the soil raises the rice,
Our hometown, is in the beautiful Yilan.

Wu Shi-he "Beautiful Lanyang"

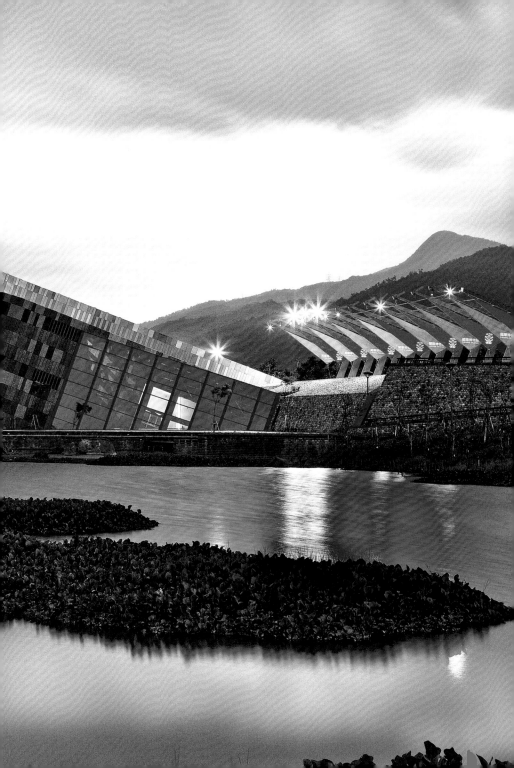

Embracing the Land

Based on the form of a cone, the silhouette of the Lanyang Museum building is designed to mimic a cuesta or a ridge with a mild slope on one side, and a steep one on the other side, which is a landform frequently observed at the northeastern coast of Taiwan. The highest point of the building faces the Guishan Island at the east, and descends into Provincial Highway No. 2 along the southwestern side. To blend the building into the surrounding, the tilted wall is erected from the ground to simulate standing gigantic rocks, delivering a spatial sense of a forest of dark stones.

Many huge dark stones exist in the onsite waters. The architecture exploits materials of similar texture and applies spatial arrangement techniques to aptly incorporate the rocks as a part of the landscape design. 🌺

The highest point of the building faces the Guishan Island at the east, and descends into Provincial Highway No. 2 along the southwestern side.

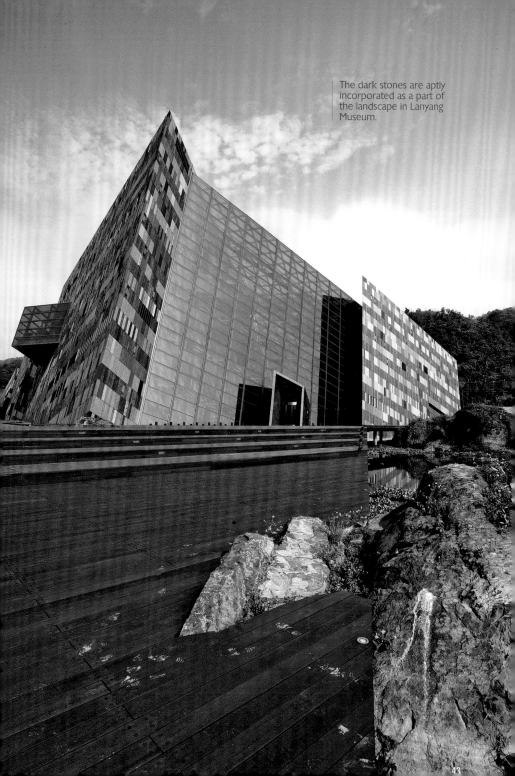

The dark stones are aptly incorporated as a part of the landscape in Lanyang Museum.

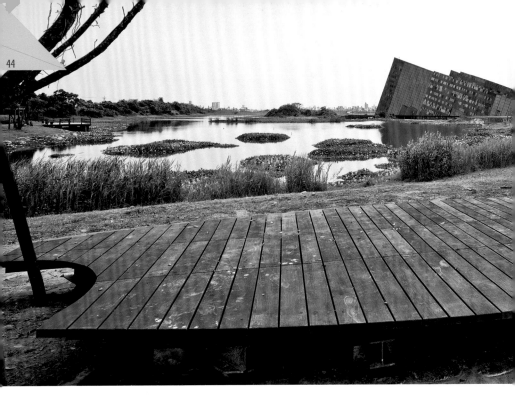

Reserving the Variety in Nature

An ecomuseum has an important mission: exhibiting undiscovered venues of meaningful historical values and bringing people close to the cultural heritage. For this reason, the main body of the Lanyang Museum is concentrated at the northwestern wing, to reserve as much as possible the old Wushi Port wetland on the other side for eco-watch, recreation, and environmental education.

All dark stones onsite are reserved for their historical significance and geological feature. To get a good view of the dark stones, visitors can go

A boat-shaped wooden platform is located along the northern parking lot, once the river mouth and stood a stone tablet meaning "spring sails in the stone port," enabling visitors to overlook the widest axis of the wetland.

on elevated wooden slat paths that surround the building, or to overlook the Guishan Island, the spirit of Yilan, delicately lying between the stones.

The vegetation mainly focused on coastal and original plants. The west side of the museum faces the busy coastal highway (Provincial Highway No. 2). For reducing the noise and the pollution brought by the heavy traffic, the wax apple trees were kept, while more original trees, suited to grow in low sea levels at the northwestern cape, were planted.

Also, the water plants onsite remain as a tribute to nature and life, which help create an image of a heath. Other plants are grown according to the features and functions of different parts at the museum. 🌺

Taking Nature at Heart, Delivering a Human Side

Situated at the northeastern side of Taiwan, Yilan rains over 200 days in a year. With the floods, typhoons and earthquakes continuing to strike the area each year, you may wonder how the scenery stays renowned for great mountains and waters. The truth is, Yilan people have developed skills to stay in peace with nature, especially for their intimate relation with the water.

There is always a river that cultivates every civilization. For Yilan, the water is traced to the Xue Mountain and the Central Mountains. The Lanyang River begins there and washes down the soil downhill to form the Lanyang Plain, where people gather to form a society and develop the culture and economy.

The interaction between farm village people and the environment in Yilan revealed the values of the ecological balance.

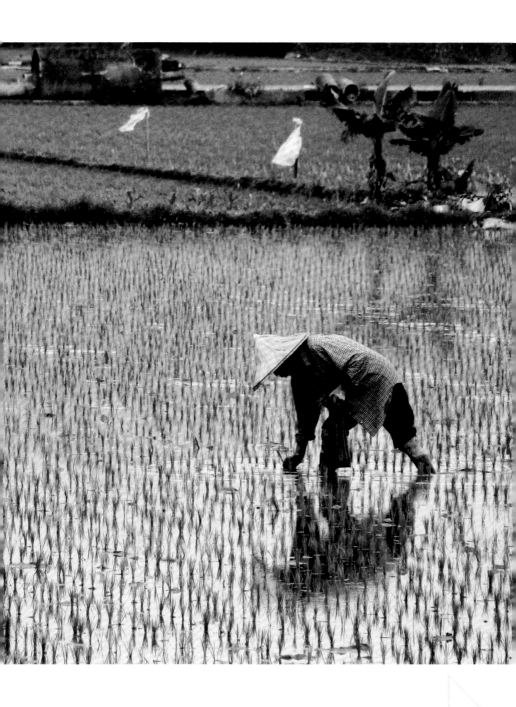

Yilan people have developed skills to stay in peace with nature, especially for their intimate relation with the water.

The Lanyang Museum has more than just relics: the display itself is a story that revolves around water, explicating the spirit that "the Lanyang Plain is nourished by the rain." Visitors would find themselves engaging in dialogue with the surrounding comprised of model displays, audios, videos, and images. The ecological landscape in the museum is much more than a simulation; it aims to showcase cultural and natural diversity. In addition to gaining the new knowledge, we truly hope our visitors to be inspired and find interests in the wonderful experiences brought by the mountains and waters of the Lanyang ground.

The layout of the four-storey interior mimics the geographies of Yilan. The Mountains Level, or the fourth floor, contains vertical glass shelves

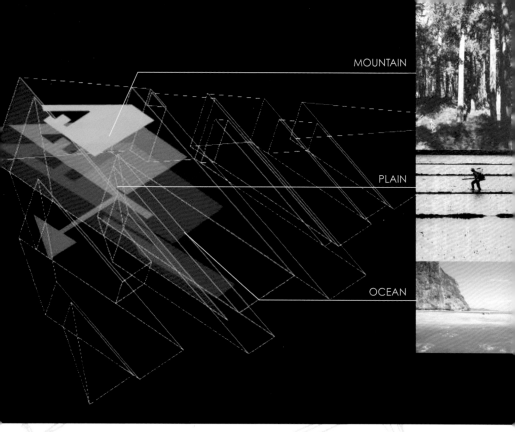

MOUNTAIN

PLAIN

OCEAN

The exhibition field
designed by Artech
Architects Inc

and large curtains to represent a foggy forest; the Plains Level, or the third floor, utilizes a horizontal display case to echo the flat land; the Ocean Level, or the second floor, comprises fluid silhouettes, to symbolize water movements and winding sand dunes.

The ceiling of the exhibition hall has scheduled performances of "A Miracle Up Above" show. Lift your chin up, and follow the water drop that leads you to see through Yilan. Finally, at the Time Gallery located on the first floor, find yourself immersed in the history of Lanyang in a different sentiment. 🌸

Presence in Lanyang

A friend asked me :
Those beautiful sceneries
Mountains, fields
Seas, rivers
How are they all moved to the northeast area ?
Ah ! My dear friend
Asking egrets and buffaloes !
Only they know the answer.

And I
Really do not know.
If you like it,
Perhaps,
Maybe I would take advantage of them when they sleep,
Putting the sounds of the river
And the green scene,
Into the envelope
Sending to you.

Wang Chao-yun "This Place"

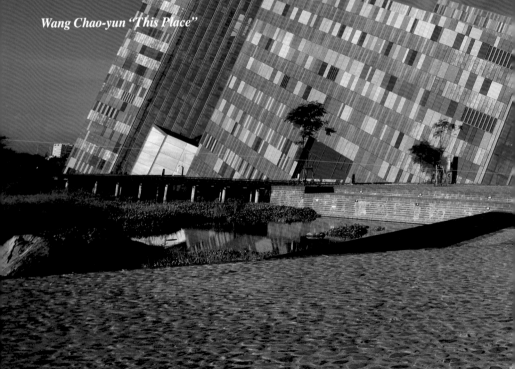

The Birth of Yilan

5or 6 million years ago, during the Eurasian Plate and the Philippine Sea Plate collision, the rocks deep in the ground floor gradually formed the island of Taiwan. At that time, Okinawa's trough rift did not affect the formation of the Yilan Plain.

With the continuous movement of tectonic plates, the Okinawa Trough gradually extended to form a depression from the southwest rift to northeastern Taiwan. For millions of years, the sands and debris accumulated to create an area deeper than 1,000 meters and 300 square kilometers, also known as the Lanyang Plain.

On the second floor of the Lanyang Museum, an interactive movie called "Birth of Yilan" is filmed. You can watch 10 minutes of 3D video about the

阿藝倌真正水，
噶瑪蘭厚雨水。

語譯：阿藝這位女子真標緻，噶瑪蘭地區雨水豐沛。
註釋：阿藝是當時人名，也是對女子的暱稱，這句話是說宜蘭地區雨
水下雨，國語雨水雙關。藉以讚美女子是以得到這麼美，這句
有押韻的談話是當地居民入境地上主的雙語。

The Da Nan'ao Metamorphic Complex

The Eurasian plate collided with the Philippine Sea Plate near the island of Taiwan. The first collision took place near the region of current Nan'ao, which made the oldest geochronology of metamorphic complex in the region reach 250 million years. Therefore, the area beginning from Nan'ao to Hualien contains the oldest rocks in Taiwan, the "Da Nan'ao Metamorphic Complex."

history of Yilan. Through four interactive games, you can better understand the morphology of Yilan, as well as its climate and customs.

The outside of the exhibition hall lies a variety of rock samples for visitors to touch and feel, demonstrating the collision history of the Philippine Sea Plate and the Eurasian plate. 🌿

Yilan Geological Time Scale

65 million to 140 million years ago, the ancient island of Taiwan was born. Ocean basins and the highlands began to appear.

10 million to 20 million years ago, the Penghu Archipelago was born.

3 million to 10 million years ago, Taiwan was officially formed.

200,000 to 2 million years ago, the Lanyang Plain was formed. The Datun Volcano erupted in the northern Taiwan.

18,000 years ago, the Taiwan Strait exposed to the earth's surface. While entering in the inter-glacial period, the sea level rose slowly, gradually submerging the Taiwan Strait.

Currently, the Taiwan Island landscape is nearly formed.

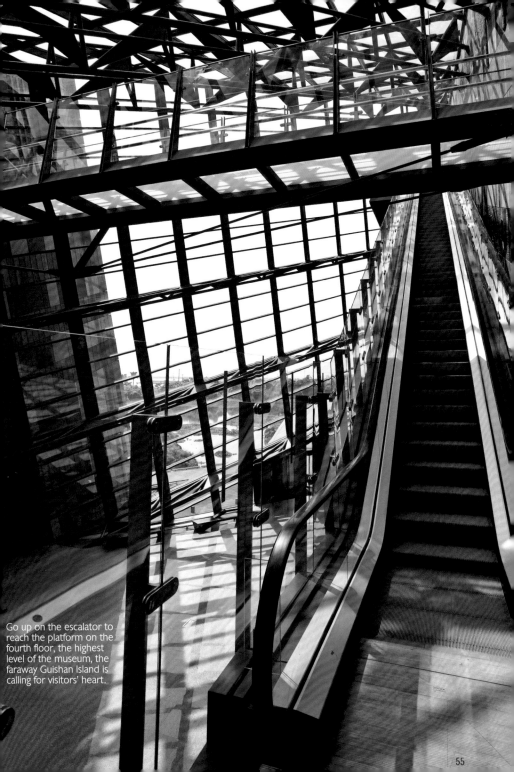

Go up on the escalator to reach the platform on the fourth floor, the highest level of the museum, the faraway Guishan Island is calling for visitors' heart.

Mountain— Motherland for Yilan

This is our youthful hill
This is our Taiping Mountain

Youthful times have passed
But the memories remain
The colors will never fade as the time goes on

Taiping is far beyond the smoke
Quietly awaiting
Peacefully strolling along its path as usual.

Li Tong "Mountains"

Natural Treasures

From the plain to the highest peak of Nanhu Mountain, the variation of the altitude in Yilan is as large as 3,500 meters. In the mid-elevation areas, there is a misty forest containing important biological resources as a natural treasure.

In the museum's Permanent Exhibition Hall on the fourth Floor, "the Mountains," the exhibition leads visitors to appreciate Yilan's biological diversity by the scenery, models, specimens, texts and images. Besides, the art and multi-level lighting, smoke, vertical curtains and glass cases simulate the forest atmosphere.

The curtain shows vigorous running of the Atayal hunters, giant cypress forest, relict ridges on the ice plant of Taiwan beech, mountain and lake sceneries, which are the most characteristic features of Yilan.

Cypress Forest Area

The visual focus of the cypress forest area is on the second generation of wood. Because cypress seedlings are often grown on fallen trees, tree trunks or high stone base, they grow outwardly from the sides of the rocks or fallen trees to keep themselves firmly rooted. When the seedlings grow into trees, the roots begin to extend to the ground, and the fallen trunks would decay to form a hollow inside, standing like a giant with feet open.

After decomposition by other organisms, fallen leaves on the ground become debris. The leaves and debris not only allow the soil to maintain a

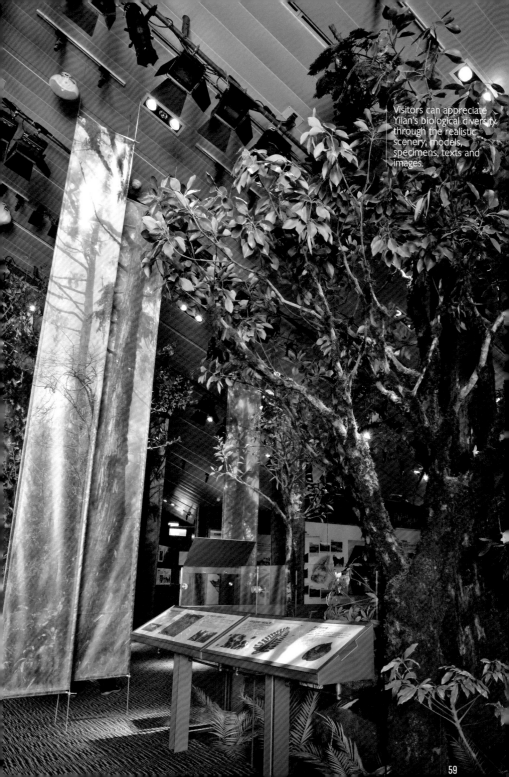

Visitors can appreciate Yilan's biological diversity through the realistic scenery, models, specimens, texts and images.

Visitors should slow the pace to see the various creatures living in the forest area.

steady temperature and humidity, but also provide an excellent resting ground during winter.

Here, one may lower the head to see which tiny creatures live in the leaves.

Glacier Relict Plants

During the advent of the ice age millions of years ago, polar ice sheets grew and sea level fell. Because the Chinese mainland and Taiwan's land mass were connected, gymnosperms migrate to warmer plains along southern China and Taiwan. However, during the interglacial period, the earth's temperature increased, the ground was no longer suitable for these plants. The rise in sea level between the island and the mainland eventually cut off connection between Taiwan and China. These spores had to seek upwardly to find a more appropriate environment. Since then, these plants had existed in 1,000 to 2,500 meters above sea level.

Today, various ice age relic plants still exist in Yilan, like gymnosperms, such as yew Lanshan, Xiao Nan, Taiwan fir and konishii, as well as angiosperms, such as Shang Tong Zi, Jiadong, incense tree, Fagus and Bird-lime Tree.

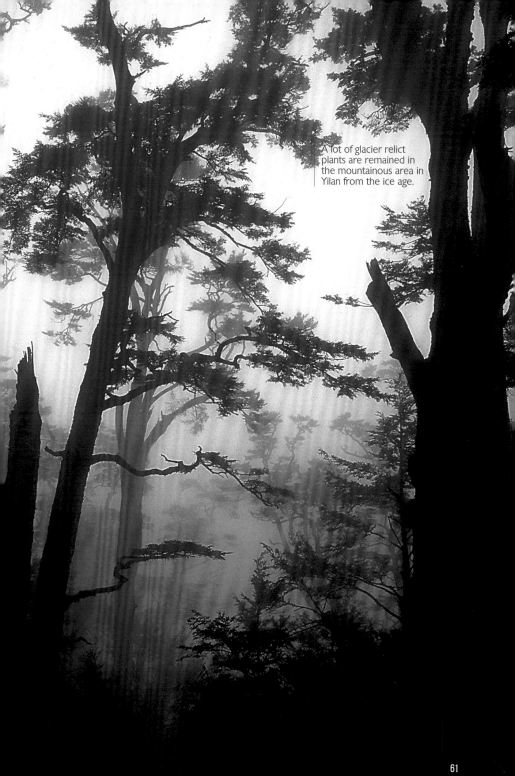

A lot of glacier relict plants are remained in the mountainous area in Yilan from the ice age.

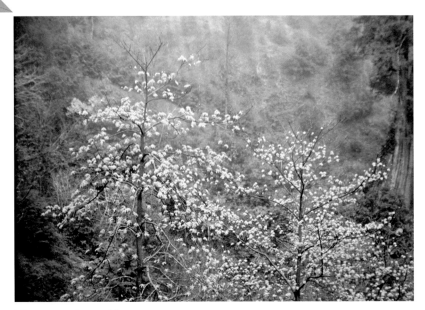

Taiwan sassafras would blossom its golden flowers in spring before growing leaves.

Taiwan Sassafras

Taiwan sassafras is a glacial relict plant that buds in late autumn each year and blossoms its golden flowers during March and April, before growing leaves.

Taiwan sassafras is also known as the host tree of the national butterfly (Broad-tailed Swallowtail Butterflies). The female butterflies lay eggs on Taiwan sassafras leaves. When new leaves emerge in spring, the newly hatched larvae would feed on them before turning into pupae, and grow into adults. That's why butterflies are always flying near the mountains with Taiwan sassafras.

The Growth of the Broad-tailed Swallowtail Butterflies

Eggs — Origin of Life
In March, the Taiwan sassafras grows new leaves, which leading the Broad-tailed Swallowtail Butterflies to lay their eggs on the red leaves or the newly-budded green leaves. The butterflies tend to lay the eggs on an open land with sufficient sunlight, especially on small trees with the diameter of less than 30cm.

Growing Larvae
The larvae like to live on the midrib or lateral veins of a leaf's surface, while splitting wires to fixate their positions. Older larvae would even roll up the leaf. They focus on feeding and growing at this stage, and they would also form protective colors according to the environment, mostly bearing a color similar to the background, for defending themselves. Larvae between one and four years old look just like bird feces to avoid predators.

Transformation of the Pupa
Finally, pupas form from larvae. They reside at the thick Taiwan sassafras branches, or under small shrubs and fallen trees with shielding function. Sometimes the location is even 10 meters away from host tree.

Emergence of Butterflies
The length of time for a butterfly pupae to emerge varies. Non-dormancy ones can emerge immediately; for dormant ones, emergence would take place after winter. The butterfly adult crawl from the gap formed by the crack of the cocoon. First emergence of the butterfly requires their body fluid to be pumped into their wings to help spreading. When the wings dry up, the process is complete.

The Taiwan Beech

Taiwan's mountain forests are mostly evergreens, but in Yilan's Tong Mountain, when the temperature declines in autumn, the leaves in the beech forest would turn red and shade the entire hill. In winter, the scenery becomes bleak when the leaves fall, but once spring comes, beech trees would grow a new core of branches as they turn green.

The Taiwan beech is a glacial relict plant, and similarly, butterflies named Sibataniozephyrus kuafui Hsu & Lin reside around them. Their larvae would feed only on the Taiwan beech, and when they grow to adults, they become particularly fond of sunshine. However, the Taiwan beech grows in the wet and foggy mountains, so it is difficult to have the afternoon sunshine in most of the time. The sunlight only streams into the woods in the early spring afternoon, the season for them to fly around elegantly. Hence, the behavior inspired scholars to name them after Kuafui, a man always chasing the sun in a Chinese epic.

Mountain Lakes

The rainy climate in Yilan causes the water to accumulate in the saddle or valley, and easily form into a pond. Barrier between the waters and land hampers the mating between the aquatic breeding. This insulated ecosystem leads to formation of independent evolution, and therefore cultivates many endemic species in this area.

The Yuanyang Lake is an excellent example of the mid-elevation lakes. It is rich in temperate

plants and East Asia Sparganium. Shenmi Lake contains submerged plant species with a complete succession. Polytrichum is the representative of aquatic plants in Tai Chi Pond; Cao Pond is the nation's only remaining environment for the Taiwan Alismataceae, while also containing the smallest dragonflies of Taiwan — Nannophya pygmaea.

The Shuanglianpi is the national treasure of Taiwan's wetlands, giving birth to diverse floras and faunas with a unique floating island environment. The Lunpi Pond, a pond formed before the landization with the altitude of about 820 meters, is covered by Brasenia schreberi that is rare in Taiwan.

The Shuanglianpi is the national treasure of Taiwan's wetlands.

Camphor Formulation

The Camphor is a commonly seen species found in the low-mountain zone in the central and northern Taiwan. The trees have fine wood textures and are often used to make furniture and sculpture. The whole plant can be refined into various products, like camphor, widely used for industrial purporses, camphor oil, and aromatic products, which are waterproof and can prevent pests. After the invention of smokeless gun powder, the low-mountain zone with rich camphor in Taiwan became an area for western countries to fight for.

The forest of the Camphor in Yilan is preserved excellently in either quality or quantity by being discovered late. During Mid-Qing Dynasty, camphor trees were mainly used for the construction of warships; in Japanese Colonial Period, the government developed the mountain resources, attracting capitalists to these areas for camphor industry.

The tools to distill camphor

The workers first cut down the camphor tree, shave them into sheets and wood chips and then collect them to put into a container to carry back to a hut for production of crude camphor. The camphor sheets are placed in a large wooden bucket for distilling. Camphor oil can be isolated through cooling process as the steam run through the pipeline.

Camphor affects not only indigenous Atayal people, the capitalists and the government, but also the future development of the Taiping Mountain Forest.

Taiping Mountain Forestry

The development of forest resources dramatically changed the industry structure in

Camphor Production Process

1.The camphor tree is shaved into small pieces after being cut.

2.Distillation process

Yilan. In the early 20th century, the Japanese found dense coniferous forests in the mountainous area of the Lanyang River upstream. The timber in the early days was delivered to Yuanshan Township Office by Lanyang River. In 1921, railway system was introduced in timber transport. Tracks lie along the right bank of Lanyang River, which gradually shift the forest management and storage to Luodong and brought prosperity to the town.

In 1956, the government established a veterans' construction company to construct the Central Cross-Island Highway and develop the forestry resources along the way — many middle-aged Yilan locals would remember the large red trucks loaded with giant tree trunks and cypress roarring on the Yilan Line of the Central Cross-Island Highway. 🌿

The mode of woodcutters transporting the woods

3.Cooling process

4.Camphor sands and oil

5.Camphor plant

The Han people mostly took 2 directions when entering Yilan from Taipei. One is Danlang Ancient Trail northbound; the other is Danlang Convenience Trail southbound.

Routes into Yilan

The Xue Mountain and the Central Mountains blocked not only the rain, but also the Han frontiers. An adage "doubts to seeing the family ever again begin to rise when climbing over Sandiao range" reflects the hardship for the 19th century Han developers to enter in Yilan.

Despite the short distance, the development between Taipei and Yilan is 100 years apart. The winding roads were conquered by adventurers at a much later pace.

The Han people mostly took 2 directions when

entering Yilan from Taipei. They would either cross the Xue Mountain via the northeast coast, taking a longer but safer route known as Danlang Ancient Trail, or they would go straight to the boundary between Toucheng and Jiaoxi via the south of the Taipei Basin. This route is known as Danlang Convenience Trail, which is shorter but more dangerous.

Caoling Ancient Trail

In the 18th century, to travel between Taipei and Yilan, one would start from Taipei and enter Nuannuan and Shuangxi via Badu, then pass through Sandiaoshe, a place mostly resided by the Ketagalan, and Longlong Range to reach the coast of Shicheng in Yilan. This is known as the Longling Ancient Trail. The Longling range lies at the northern part, and

Follow the circuit to feel the hardship for the ancestors to pass the trail on foot.

therefore a Caoling Ancient Trail was eventually formed to connect Shuangxi, Xue Mountain, Dali, and the coast of Lanyang.

Trails in the Qing Dynasty were mostly built along mountains and terrains, and were mostly twisted and winding. Caoling Ancient Trail is still a famous tourist and leisure trail. Today, the roads are no longer difficult to complete on foot, yet a visit would still suggest the hardship of the past.

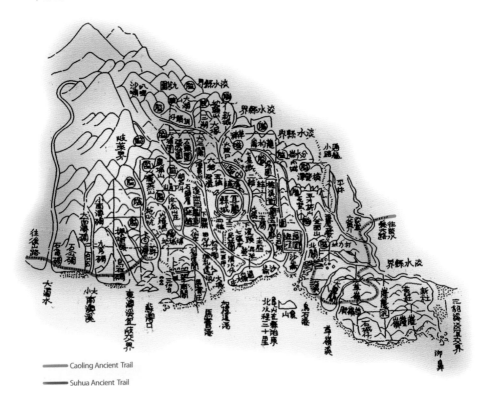

▬▬▬ Caoling Ancient Trail

▬▬▬ Suhua Ancient Trail

Inscriptions of "Tiger" and "Boldly Quelling Savage Mists"

Fogs often obscure Caoling Ancient Trail and make it hard to identify the direction. Admiral Liu Ming Deng, coined the terms "Tiger" and "Boldly Quelling Savage Mists" to conquer the dangers of these landscape features of the township when he visited Yilan.

Suhua Ancient Trail

Traffic between Yilan and Hualien was blocked by the faults; therefore water transportation was very important in early days. In 1874, because of the "Mudan Incident," the Qing Dynasty decided to strengthen its governance of Taiwan. The imperial court decided to take advices from Shen Bao Zhen, the imperial commissioner, and began to implement the strategy of "develop the mountains and pacify the indigenous." Later, the imperial government brought large labor force to build Suhua Ancient Trail to connect between Yilan and Hualien. 🐾

Plain—
The Hometown to Rain

Green pasture comes before the eyes
From the plains and from the mountains
One could not see the bottom of the mountain
One could only see green brocade that tightly wraps around it
Mountains and valleys that border the clear blue sky
Mountains on the left
Sea on the right
Together with the mountain and the sea, we make magnificent company of three
Cold wind from the pine waves and the large waves
Waiting for you to grow waiting for you to mature
Waiting to see your beauty once you are fully grown

The green colored plains stretch beyond the horizons
Rice paddies are smooth pieces of emeralds

With layer of golden sunshine that shines upon it
Lovely jaded color waves surge whenever the wind blows

The deep green colored sea is cold and dark
Even the rocks that watch day in and day out
Could not see through the width and depth of the Pacific Ocean

The Lanyang Plain that lies between the mountain and sea
Is still a simple and refreshing morning
Beyond it is the climax built up at Suhua highway
And a splendid mid-noon

Rongzi "The Lanyang Plain"

The crisscross path of the farmlands is the beautiful scenery on the Lanyang Plain.

Abundant Water Resources

Going down from the Mountains Level reveals an image of Niudou. This is the gateway from the Lanyang River's mountainous area to the plain.

2 million years ago, the Lanyang Plain was covered with sea water. But with the slow piling up of the Lanyang River's delta and the uprising of the land, causing the coastline to stretch eastward, the grandeur of alluvial fan in the shape of a triangle appears before the eyes.

The Lanyang Alluvial Fan Plain has gravel as base and is highly permeable, while mountainous water mingling and penetrating here to make an underground water depository for the plain. The water flowing from the alluvial fan with the contour interval between 10 to 20 meters has been filtered through layers of sand; it is sweet and clean. It was

in these spring areas that ancient locals built their homes, drank and irrigated lands.

The abundant rainfall, rivers and springs, gave birth to fertile lands but also brought numerous disasters. The battle of survival between man and water starts here.

The third floor of the Lanyang Museum takes the tourists into the Ximen Terminal in the year of 1920. Standing beside a character, one can hear the "voice" of the character and understand what life was like back then.

The good mountains and pure water in Yilan make high-quality hot spring vegetables.

Han people's culture is seen through the interaction between farm village people and the environment, and the values are brought about by the balance of ecosystem. The exhibition area is composed of the idea from the view of the ground and the paddy field with ponded water, reflecting the logics between the water and the land in the real world.

At the southeast wing of the Plains Level is a big window allowing the tourist to have a look at the wetland and listening to the Yilan-folk music.

Chronicle of Hot Spring

The earth is a gigantic heat reservoir with endless energy. Rocks, volcanic eruptions, hot springs, and so on reveal the boundless living force of the earth.

Yilan County's geological structure is unique. Underground heat source lies in the fault zone, and abundant underground water surfaces through cracks of the faults to form two of nature's treasures, "Su'ao Cold Springs," and "Jiaoxi Hot Springs."

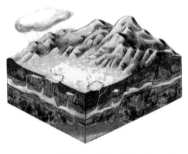

The sectional drawing of the formation of the hot springs' geology

Jiaoxi Hot Springs

Hot springs can be found all around Taiwan, especially in Yilan County. Jiaoxi Hot Springs has been circled for the use of bathing by the aborigines, the Han nationals cultivating lands during Qing Dynasty, and Japanese. Today, Jiaoxi remains a well-known town for in the Northern Taiwan for its hot springs.

Jiaoxi is one of the rarest hot spring areas in Taiwan as it is uniquely located in a plain. It is a

carbonated spring, colorless, odorless with great water quality. Known as Tangwei Hot Springs in Qing Dynasty, it was also named one of the Lanyang's eight scenic spots.

Jiaoxi Hot Spring's pH level shows slight alkalinity, which balances off the acidity of the soil. Vegetables irrigated with hot spring water grow well and fast. Even during winter, the hot spring temperature is 25 to 28 degree Celsius, providing the best growing environment for vegetation. In recent years, Jiaoxi Farmer's Association has made the most use of hot spring through developing hot spring vegetables, hot spring mineral water, and warm-water fisheries.

| Su'ao Cold Springs Park

Su'ao Cold Springs

In 1895, when Taiwan was ceded to Japan, Japanese soldier Takenaka discovered the spring water in Su'ao and found it refreshing after drinking. After completing his military service, Takenaka returned to study the cold springs and found its healing effect, while sinking a well for people to take the bath in the pool. By 1907, a carbonated drink with marble called "Namunei," was produced by adding spice and sugar to the spring water, placed in a glass bottle. The elderly in Yilan still reminisce about the drink up to this day.

The cold spring area is located at the North of Su'ao town. It is a low temperature mineral spring with a temperature below 22 degree Celsius. The water is colorless, odorless, crystal clear, and emits a large amount of carbon dioxide. It can be used for both drinking and bathing.

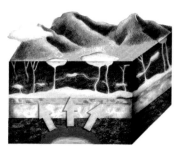

| The sectional drawing of the formation of the cold springs' geology

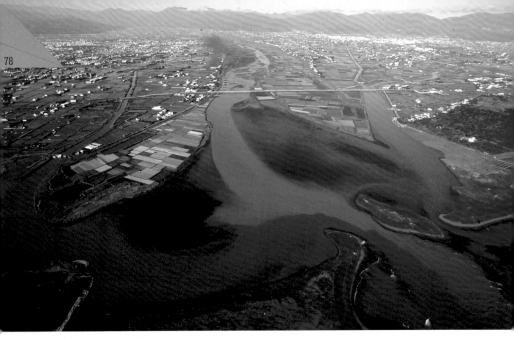

The confluence between the Yilan River, Lanyang Creek and Dongshan River (from the right to left)

River Engineering

Since the rivers located on the Lanyang Alluvial Fan Plain would easily detour to the lower level once the river bed deposits higher than the topology of fan by two sides, as the rivers did not deeply cut into the ground, as well as the deposition of gravels. The cycle made the watercourse on the fan-delta plain mostly show a web-like pattern, especially in the downstream plain. In these areas, the flat slopes, slow water flows, meanders and splitting watercourses all lead to more detours amid heavy rainfalls or river overflows on the older days lacking of water conservancy and flood control constructions.

Rain and Wind All Year Long

Yilan experiences heavy rains in autumn and winter. The rainwater converges at downstream

area of the Zhu'an River, Dezikou River and
Dongshan River, as well as low-lying regions with
lower than three meters above the sea level, which
results in frequent flashfloods, as the substantial
water is unable to flow into the sea quickly.

Flood Control Projects

Yilan experiences frequent flood disasters. Since
the Qing Dynasty, local residents have initiated the
repair of temporary facilities every now and then. But
when faced with bigger flashfloods, dike failure would
occur and endanger the safety of local residents.

During the Japanese colonial ruling, modern
techniques were introduced to channelize water
current and to construct embankment, such as
the embankment along the Yilan River by Yilan
Governor Saigo Kikujiro, the flood control projects
completed up North of Lanyang Creek in 1929
and the embankment project of Lanyang Creek in
1936. More projects were completed after the war,
including straightening of Dongshan River. 🏵

Ethnic Groups and Cultivation

If the Han people belong to the plains, the Kavalan are the people of water, and the Atayal tribes are the children of the mountains. These different ethnic groups each brought their cultures to settle at the Lanyang Plain one after the other, and developed a bond with the land.

The story of their encounters with the Lanyang Plain will pass on through generations.

The Kavalan's wood sculptures are mainly bas-reliefs and thread sculptures for decorating walls of the building.

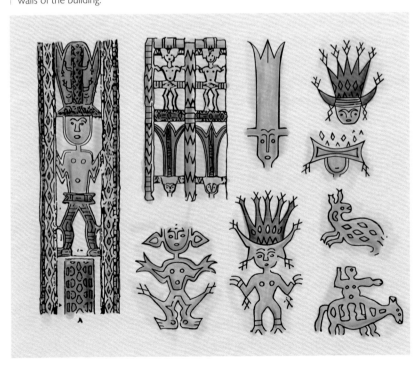

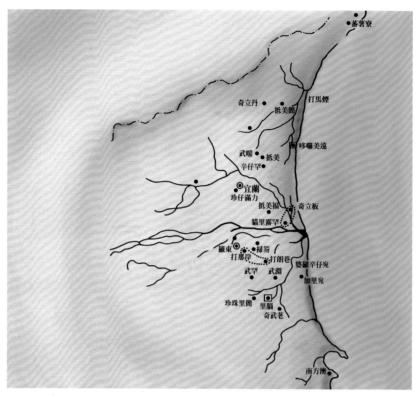

The distribution of the Kavalan tribes on the Yilan Plain in the early 19th century

Water and Livelihood of the Kavalan

In the Spanish historical data in 1632, Lanyang Plain was referred to as "Kavalan." There were approximately more than 40 Kavalan villages. When the Dutch conducted a household survey in 1650, there were 45 Kavalan villages with a population exceeding 10,000 people, a Pingpu tribe with the highest density of people in the Northern Taiwan. It also shows how rich the locals were with abundant resources.

Living in the river shore, the Kavalan has a close bond with the nature as seen in their rituals, culture, observation of the climate and other natural phenomena of season and weather, among others. They take advantage of the natural resources and turn them into fishing and hunting tools, raw materials for weaving, construction materials, vessels and other things. A document dated back in 1722 recorded that the Kavalans used "Monga" (canoe) to ship the military men from Yilan seashore to the North coast. Apart from canoes, Kavalans also build bamboo raft for fishing and transportation.

Active Mountain Life of the Atayal

The Atayal tribe (also called Taiyal), meaning "True people" or "Brave people," is known for its fierceness and bravery. Sometime in the 18th century, Atayal tribes originally from Nantou mountainous area travelled northwards and eastwards; by mid of the 18th century, Atayal migrated and settled at Heping North River and Nan'ao South River. Currently, the Atayal tribes mainly reside in Nan'ao town and Datong town.

Atayal people have long lived in the mountainous area and co-habited with the nature. Their livelihood is mainly the cultivation of land, weaving and hunting. Trakis (millet) is the tribe's main staple and is considered holy. A series of rituals are held during sowing, thinning and harvesting.

Responsibility of the Atayal Females

Atayal females are skilled in using ramie in weaving to produce bed sheet, blankets, cloak and belts. Ramie fabric weaving is also the most developed technique within the Taiwan indigenous groups. The ability to weave is also an indicator for the Atayal female's turning into adulthood and a basis of the society's assessment on females.

The Han Pioneers

The Han people started to cultivate lands in Yilan about 1797. Their mode of cultivation is carried out through armed groups. A capitalist would finance the cultivation through a leader who recruited workers to develop the lands. These workers were divided into units and worked under the supervision of the leader. Upon completion of the cultivation, workers got to draw lots to own lands.

The Han people brought skillful canal excavation and farming techniques. They cultivated the land following the spring belts, while constructing and

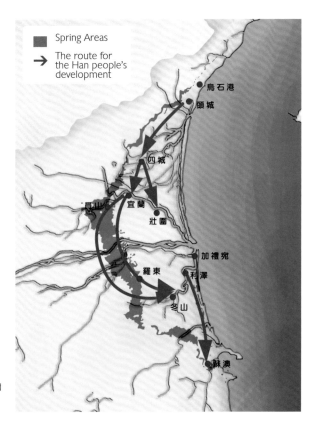

Spring Areas

→ The route for the Han people's development

烏石港
頭城
四城
員山 宜蘭
壯圍
加禮宛
羅東 利澤
冬山
蘇澳

The roadmap that the Han people developed in Yilan in the early 19th century

repairing canals to irrigate, further sending the water to every rice paddy in the region, contributing a lot on the farming industry in Yilan. The lower water rent makes the farming cost relatively cheaper in the region than in the Western Taiwan. Once there were remaining products by the end of the year, farmers exported them, further making Yilan one of the rice granaries in Taiwan.

In the earlier years, the routes of dike construction and land cultivations were almost

similar, making it a distinct feature in developing Yilan. For the first 20 years in the 19th century, land area of the Lanyang Plain was quickly turned into paddy fields. With the expanding scale of cultivation and Han people's advantage over the land, Yilan soon attracted investment from numerous capitalists, and water industry started to prosper.

Paleography on Jin Ji Longs

In the year 1860, Jin Ji Long was a group or the so-called land development company that cultivated land in Jiaoxi Township. The historical record showed Lee and 8 other stock holders' transaction details of commissioning the land cultivation, allotment of workers for cultivation, and mode and quantity of land exchange. The record shows the details of how the capitalists cultivated lands during Qing Dynasty. A contract was used in land ownership after the land was cultivated and lots were drawn to decide the ownership.

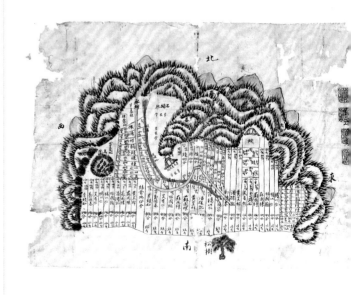

Discover the hostility and fights for surviving between the Han and the Atayal from Zhou Residence in Yuanshan Town.

When the Han Met the Atayal

The mountainous area near the Lanyang Plain used to be Atayal people's hunting place. When the Han people entered Yilan for cultivation 200 years ago, dispute rose over the land between the two groups and lasted for two centuries.

Traditional Atayal people often resorted to cutting off their enemies head to decide on the dispute between or within the tribes. This was the biggest threat to the Hans living by the mountainous area. The Atayal's Klesan and Mnibu groups often attacked villages along the mountainous area. Garrisons were then put up to prevent Atayal tribe from attacking.

The border between mountain area and flatland was where the locals were often harassed and bandits targeted their victims, as the government would be negligent in safeguarding the region amid its sparse population. Private residence must set up its own security facilities for self defense. The preserved historical site shows how the security system was setup in private residence back then. 🌺

Zhou Residence in Yuanshan Town

In the beginning of the 19th century, Zhou Ding, who was originally from Fujien came to Dasanjiou at Yuanshan town in Yilan for land cultivation, and became very wealthy later in life. Zhou owned more than 700 acres of fertile land, and received 15,000 stones of crops as rent each year.

Zhou Cheng-dong was the fourth son of Zhou Ding, as well as a successful candidate in the imperial examinations at the provincial level in the Qing dynasties. He built a house at the foot of hill in Hudong village. Zhou's new residence was situated at the border of mountainous area and flat land. It faced a river and behind it was a mountain that looked like a lion's head. There was a ball-shape mound in front of the house. Fengshui considered this to be a lucky place.

For the security reason, Zhou residence had holes for shooting firearms built around the walls. There was a 2 storey-high bunker on each side of the house, used as a hiding place in case of attack from aborigines or bandits. Even the abduction often happened around the region of Dahu, it never hurt the Zhou family in their well-guarded residence.

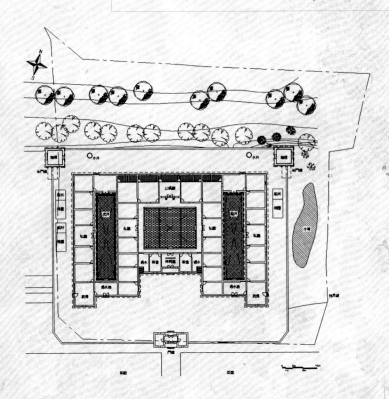

Chronicle of Customs

The Lanyang Plain was a stage that showcased different ethnic groups and cultures at different periods. According to historical data, there were already settlers as early as 1,200 years ago. Hundreds of years later, Kavalan settled near the wetlands by the sand dunes, before a large number

Zhongyang Festival's Grappling with the Ghost in Toucheng

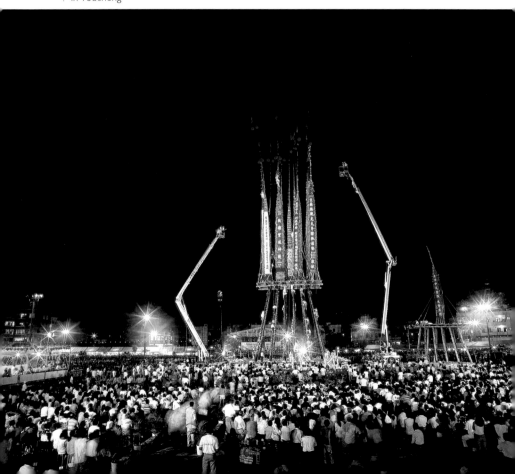

of Han people migrated to the Lanyang Plain around 200 years ago. Hence, these movements cultivated a multi dimensional, cross ethnic culture, as well as religion and tradition. Traces of mixed Kavalan and Han culture can be seen everywhere.

Living in the environment of disputes and distress among ethnic groups, ancient settlers turned to religion and customs for spiritual sustenance. The Ghost Festival in Toucheng, the Dragon Boat Festival in Erlong village, the exorcist stones in Zhenshui, and the worships of the dikes would all be the interactions between the Lanyang settlers and their environment.

Sandu Expresses Gratitude for Safety

Sandu, an area in Wuyuan village of Dongshan town is situated at the low-lying area by the riverside. It experiences flood disasters almost at the end of each year. Residents of Sandu always wished for safety at the beginning of the year, praying for peace all year long, and at end of the year would express gratitude. The ritual is common in Taiwan, but the ritual in Sandu has special characteristics. In the morning of the worship, the person responsible for organizing the ritual would have to dig out a portion of soil along the Dongshan River and put it on the worship table to be worshipped along with other Gods.

It is said that when Sandu held the gratitude ritual at the end of the year, the locals would invite families and friends to join the feast. However, the guests were often afraid of attending the feast because the tribe would have so much water

During the ritual of "express gratitude," the soil dug out would be worshipped with god by people.

retention from flooding, making the area more like a large water pond. At the end, the residents would have to celebrate the feast on their own.

With harsh living environment and unpredictable climate, Sandu residents have become even more respectful for and dependent on God's protection and devotedly express gratitude for safety year after year.

Zhongyuan Festival's Grappling with the Ghost in Toucheng

In 1797, Wu Sha led a group of frontiers to the South of Wushi Port and started a large scale of land reclamation. It was said that in memory of those who died during reclamation, a ritual was held in front of Qingyuan temple. This was also the start of "grappling with the ghost."

Toucheng's "grappling with the ghost" takes

Toucheng's "grappling with the ghost" takes place on the 7th month of lunar year and at the midnight of the last day of Zhongyuan Festival.

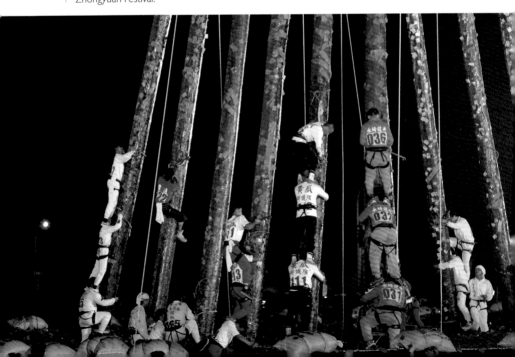

Getting to Know the Guzhan

Before the Zhongyuan rites in Toucheng, each district unit known as "Li" has to produce a Guzhan and transport it to the venue on the day of "grappling with the ghosts." A Guzhan is a cone-shaped structure placed on top of "Gupeng," a platform measured 11 meters in height and 8 meters in width. Each "Gupeng" is supported by 6 pillars with each at 13 meters tall. The Guzhans placed on the four corners of the Gupeng are unchangeable for four specific villages, while the rest villages do not place their Guzhan in a fixed place. But basically, the location for each village to place the Guzhan has become a custom through long usage.

Water Lantern

On the night before the "grappling with the ghosts," worshippers would be taken to the Zhu'an river mouth to release water lanterns. The light from the lantern is a guide for spirits in the water to come ashore and attend the rites the following day. In order for the water lantern to flow farther, the release time is set during ebb tide and lanterns are released at the mouth of the river.

Dakeng village is responsible for the release of the water lanterns. Previously, a band was hired to participate in the procession to make the event livelier. Before the release of the lanterns, names of the organizers, those who helped finance the event and those who sponsored the boats were all read out as part of the prayer for the safety before setting out.

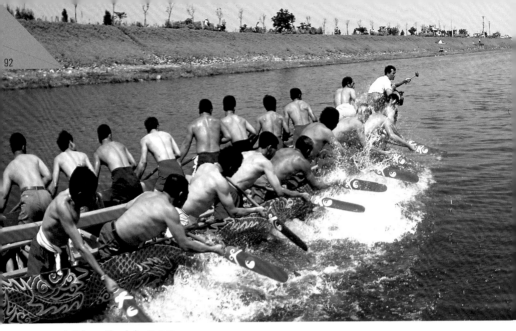

Erlong village's boat race
is the lively local activity in
Yilan.

place on the seventh month of lunar year and at
the midnight of the last day of Zhongyuan Festival.
Participants would compete to climb up the
"Gupeng" (the lonesome rack), and then throw the
food to the ground for the onlookers to grab. This
symbolizes feeding the ghosts and keeping them
away from hunger. Apart from commemorating
the deceased, Zhongyuan Festival has an underlying
meaning of empathy.

Erlong Boat Race

Many of Yilan's customs are connected with
water. For example, there would be the boat
race on the fifth day of the fifth lunar month. The
transport of sugar cane and river sands are through
boats. The first boat to travel in a day must offer
paper money to pray for safe trip throughout the
day. If someone dies in the family, the ancient

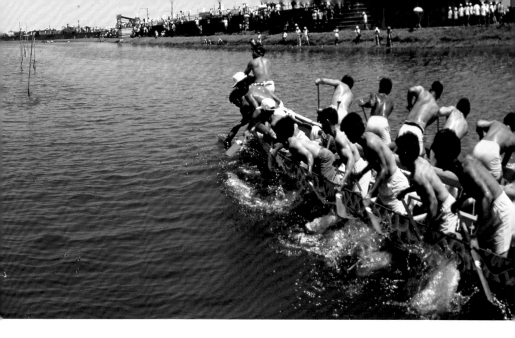

tradition requires "asking for water" from the river to bathe the deceased.

Erlong village's boat race first began as a traditional activity for residents at the downstream of Dezihkou River. It is special that it has no referees, no one to call for the start of the race and no one to record the time. Audiences on both side of the river are the referee. If a participant of the race has any objections to the results, the race will have to start over.

The schedule for boat race in Erlong was not regular but mostly maintained at the slack season for farming. The festivity would sometimes last for 12 days and there would be shows by the river shore. The race was forced to cut down to only 2 days during the time of Japanese occupation, but it was determined to take place on the fifth day of the fifth lunar month in 1965. 🌺

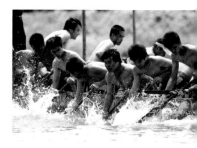

Erlong boat race has been determined to take place on the Dragon Boat Festival since 1965.

Water Transport That Flourished Lanyang

During the Qing Dynasty, there was a lack of roads and bridges, so river transport played an important role. West and East harbors were important gateways. As the rivers converge at the downstream, the boats could freely sail through to pick up and deliver goods between ports.

As flash floods worsen, rocks were washed off from the mountains and blocked the river paths, and with the construction of railways and highways, river transport gradually faded.

Tools for River Transport

The ancient Yilan City is situated in the middle section of the Yilan River. During the Qing Dynasty and the beginning of Japanese occupation, Ximen port was the center of transporting, goods collection and distribution.

During that time, cargo vessel from upstream or

The Xiashe Ferry in Yilan's Zhuangwei Township

downstream all gathered at the entrance of Ximen ditch, known as "Hankongtou." As the path of the Ximen ditch was narrow, goods would be picked up and moved to a multitude boat called "Yamu" and unloaded at the Ximen port, where they were then transported into the Yilan city, using manually pulled carts.

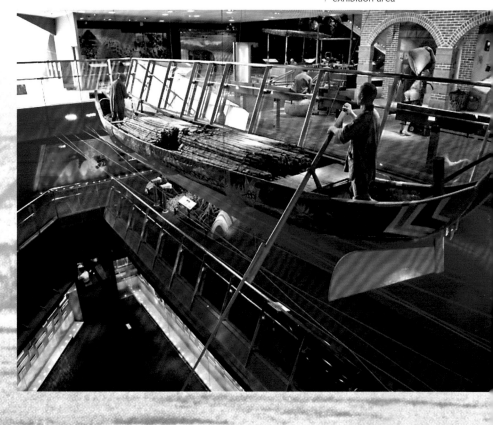

"Bo'a" (wooden) Boat in Lanyang Museum's exhibition area

Types of Boats

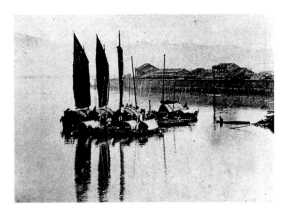

Boats in the earlier days were classified according to sizes and types. The "Anbianzai" boat was a sailboat that travels to the sea, the "Bo'a" boat through the river and was about 10 meters long, 1.5 meters wide and could load up to 1,800 kilos. Paddles were generally used when sailing in deep water bamboo sticks in shallow areas. The "Yamu" boat is similar to the "Bo'a" boat, being operated by a single person and traveling through narrow river path or shallow streams.

The ancient Qinghe
Bridge located in the Yilan
City's west gate

Ximen Terminal

In the years when transportation relied mostly
water, ferry terminal was a place where people
gather, and soon turned into busy streets filled with
shops. Ships frequently traveled in and out of Ximen
Terminal in Yilan town, which eventually gave rise to
the Ximen shopping street.

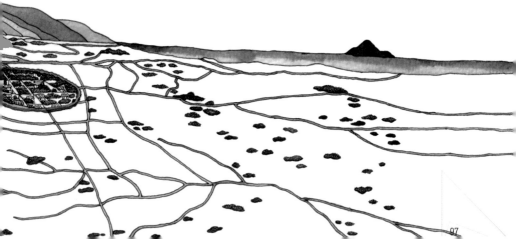

Yilan Street Guide
published in 1932

The Museum referenced on the Yilan Street
Guide that was published in 1932 and unveiled
scenes around Ximen Terminal during the Japanese
occupation in 1920: the simulation of "Bo'a" boat
transporting sugar canes, people from all walks of
life hanging around the port, workers transporting
goods, peddlers selling food, and paupers begging
money. You can hear the voice and thoughts
coming from each of the figures when standing next
to them, and get a glimpse of what life was like back
then.

Going further inside, you would see stores on
the Ximen Street, including Aozhou House —
a grocer opened by the Japanese, Zhengxian —
a store to sell Yilan rice, and Tangken —
an ironsmith. 🦙

There are people in various walks of life in the Ximen Terminal.

Origin of the "Bo'a" (wooden) Boat

The "Bo'a" (wooden) boat on display was donated by Mr. Lin Shi-shuen of Zhuangwei Township. It was used to transport sugarcane, river sand and was rented out as a dragon boat. About the mid of 1980s, it was donated to the Yilan County Government as a manifest to Yilan's water transportation in the earlier years.

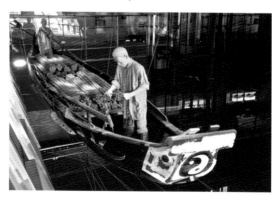

Water and Life

Yilan is blessed with abundant water resources; drinking water is from springs, laundry is done at the river, and ducks are raised around the streams. Lives of the people are closely connected with water.

Traditional Yilan residents developed various ways to obtain water: people living in the mountain region would build bamboo ducts to draw mountain spring water to a reservoir at home. For people living on the plain, they collect water from the irrigation channel by using buckets, or sink wells or use manual pumps to obtain water. The emergence of electric motors eventually replaced manual labor.

Water is closely connected with people in Yilan. There are people constantly washing things by the river.

Laundry Canopy

Yilan has abundant water resources. There are people constantly washing things by the river. Those who are meticulous would build a small pond with stone or cement and lead the water into the pond. Bamboo rack and thatch are set up to make a laundry canopy. Laundry canopy in the past are important to the community as an information exchange center. Children are also often seen taking a bath or washing their feet in this area.

The laundry canopy in Yilan in the exhibition area

Rice Paddy Culture

The crisscross path of the farmlands, the ridge between fields, the green rice seedlings and the golden crops, are all distinct sceneries on the Lanyang Plain and also the main means of livelihood. Han people took advantage of the abundant water resources and cultivated rice paddies that became a source of livelihood.

The east side of the Lanyang Plain is near the low-lying region, and farmers have to cultivate

Digging wells and using waterwheel to obtain water from low lands are common measures in the era lacking of mechanical development.

in swamps, standing on the bamboo poles to transplant rice seedlings and use the "Yamu" boat during harvest. Whenever there is flashflood or inundation of the sea, rice paddies would be swallowed out by the water. Farmers would travel, using "Yamu" boat to the flooded area to save the crops. This depicts Yilan people's wisdom and patience to try to overcome the restriction of the natural environment.

While crops grow, if there is no rain for consecutive weeks, the water level of the streams would be too low, rice paddies would lack water

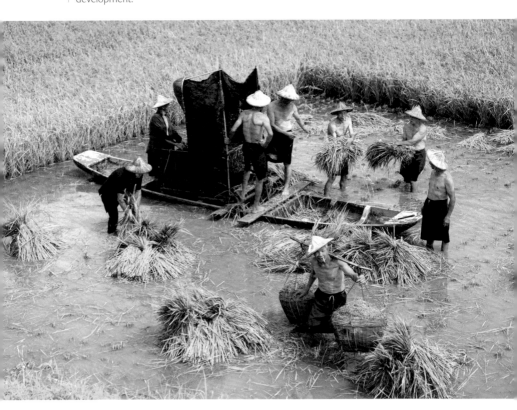

for irrigation, and farmers would dig wells and use waterwheel to obtain water from low lands. But nowadays, extracting water manually has been replaced by the use of electric pumps.

Bamboo Enclosure Traditional Residence

On the vast Lanyang Plain, the countless bamboo-fenced residence located in the region is the most distinct farmland scenery in Yilan. Farming households are enclosed with bamboo fence, with nearby farm lands for their own cultivation. Bamboo fences have become an identity of their lives.

As bamboos are tough and compact, it can be made into farming equipment and fences, and the thorny bamboo-made fences can even prevent burglary. Bamboos can be used to shield from typhoons during summer and Northeast monsoon during fall and winter. On the other hand, bamboo shoots make a delicious dish, among many other uses of bamboo.

The model on exhibit is based on the Chen household in the Dazhou Village of Sanxing Township. It shows typical farming households enclosed in bamboo fence. Thorny bamboo or Dendrocalamus latiflorus about 6 to 7 meters tall are planted at the left and right corners of the three-section compound. The culms are thick and loosely spaced; it functions as a shade, and is used as a landmark from afar.

On the front of the fence are small bamboos, trimmed to the height between 60 and 120cm and functioned as an enclosure to an open space, with the advantage of not blocking the view of the

The bamboo-fenced residence is the home for hard-working farmers to live and work in peace and contentment.



Duck-raising Families

During harvest seasons, fields would usually have leftover rice ears; the diligent Yilan farmers would use this as duck feeds. Farmers usually herd ducks in the fields or along river streams, letting them feed on rice ears that fall off, or food from the nature such as fishes and crustaceans, which are important sources of proteins for the growth of duck meat and duck eggs. The duck wastes are then turned into valuable fertilizers, benefiting the rice fields. This method of raising ducks is commonly known as "escaping the winter."

Clean natural springs can be found all around Yilan, being suitable for duck-raising and brooding business. As early as the Qing Dynasty, duck raising industry was already very much developed. After the war, the government even set up Livestock Research Institute Yilan branch, or commonly known as duck research center, which specializes in duck breed improvement. "White Tsaiya" or "Yilan duck: TLRI No. 1" with pure white feathers is the product of over a decade of researchers' breed works.

Yilan locals turns aging female ducks that can no longer breed into "Yashang," the most distinct local delicacy, with ducks pickled and smoked over sugar cane. 🌸

Yilan locals wisely smoked ducks over sugar cane to produce "Yashang," the most distinct local delicacy.

Ocean—
Life by the Ocean

The sea water absorbs the sun's warmth
and brews a uniquely intoxicating smell that
lingers in the air at the fishing harbor.

The ocean breeze tickles everyone's nostrils.
Every year from April through May,
large quantities of bonitos are brought in
by the warm currents.

In March, tug boats from around the island
gather here at Nanfang'ao Harbor. The fishing
village with four to five thousand people now
has to accommodate up to twenty thousand
people, mostly fishermen.

These fishermen, wearing a cap and sporting
a shiny tan, talk loudly amongst themselves.
Alongside, hawkers, prostitutes, and golden
flies with red heads all flock into the harbor,
closely following the influx of fish.

Huang Chun-ming "The Days of Sea-watching"

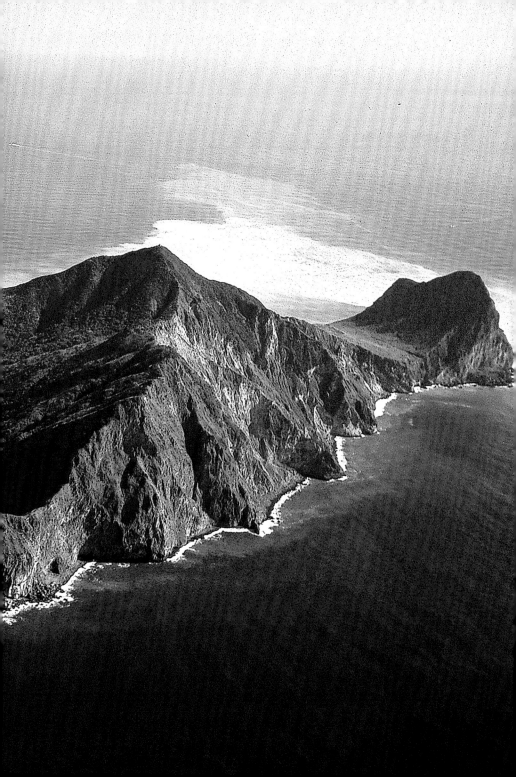

When catching sailfish, the Nanfeng No.1 would first set up a spear rack, while the main spear rack controller in charge of aiming.

Artistic Image of the Ocean

Visitors will be greeted with a breath-taking image of the Lanyang Estuary as they enter the Ocean Level. A series of dynamic images are employed to showcase the plentitude of the amazing coastline in Yilan.

The design of the exhibition space is inspired by the meandering waterways and sand dunes created by the estuary, which further transform to sand dune-shaped shelves, the main structure of the space. The installation arts of the flying fish and waterbirds connect with ecological resources and human activities, indicating the interdependence between the both.

The whirlpool-shaped Ocean Theater is inspired by the image of a surging current, depicting a fantastic yet realistic version of the underwater kingdom in Yilan. It is a magical space that is at the

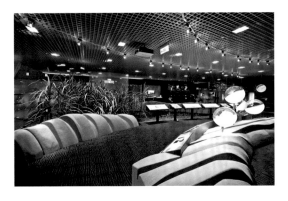

The sand dune-shaped shelves are the main structure of the exhibition space in the Ocean Level.

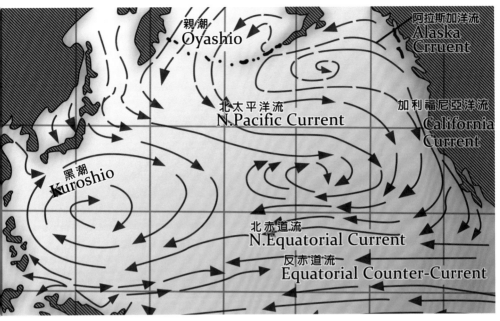

親潮
Ōyashio

阿拉斯加洋流
Alaska
Crruent

北太平洋流
N.Pacific Current

加利福尼亞洋流
California
Current

黑潮
Kuroshio

北赤道流
N.Equatorial Current

反赤道流
Equatorial Counter-Current

The Kuroshio, or the "Black Current," is in the west Pacific Ocean.

same time artistic, interactive and educational. In the center of the theater space is a piece of installation depicting a massive school of flying fish injected from the middle of a whirlpool, with dolphin fish, the predator, that pursues.

A Highway on the Ocean

The Kuroshio, or the "Black Current," in the west Pacific Ocean transports heat from the equator to the cold zone in the north. The clear water carries a dark blue hue under the sunlight, "Black Current."

The Black Current travels at a rate of 3 to 7 kilometers per hour, approximately the speed of walking by mankind, slightly faster than regular

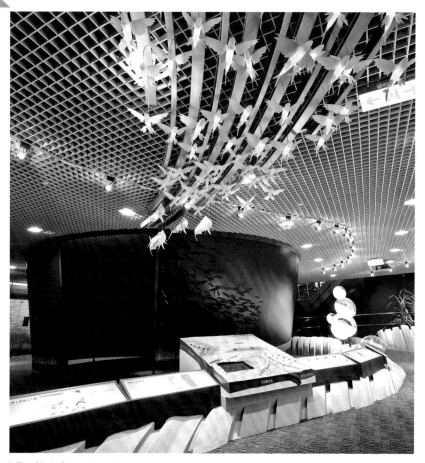

The Black Current passing through the open sea close to Yilan leads fish to gather and prey, further driving up the fishing industry in Yilan.

currents. It is a highway on the ocean that affects the climate, ecology and fishery tremendously.

Migratory Fish

When the Black Current travels to the open sea close to Yilan, the current hits underwater terrains and forms a counterclockwise surging current that extracts the nutrient-rich deep water

salt to the water surface. The sea salt breeds plenty of plankton, leading to small-sized fish's gathering and further attracting medium-to-large-sized fish assembling to prey. This helps form the fishing ground and drive up the fishing industry and the fishery culture.

Baby Eels

Eels travel frequently with the Black Current. It was not until the recent years that scientists could finally reveal the mystery of eels' life journey by taking a closer look at their ear stones. It turns out that every stage of an eel's life has been inseparable from the Black Current. In winter, baby eels travel with the Black Current to the Lanyang Estuary and start trekking upstream, where they mature. In the summer, they swim back to the ocean to reproduce. Once they fulfill that duty, their life span comes to an end.

These baby eels are about two to three centimeters in length. The small heads and see-through bodies make them look like a thin leaf flowing in the water, hence the nickname "willow eel." It takes them up to six months to swim from their birth place to Taiwan's seashore. About one month prior to reaching Yilan, they grow into some slender shaped "eel lines."

From December to January every year, visitors often see fishermen catching eels with a special hand-held net beside the Yilan's shore at night. These baby eels were then purchased by eel farmers to grow into yellow-colored juvenile eels and silver-colored adult eels. 🌺

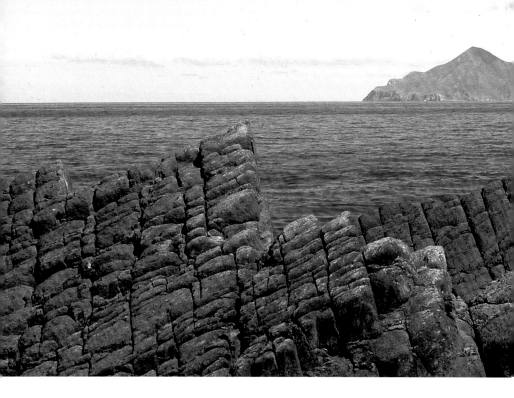

Secret Under the Ocean

The complex underwater terrains off the coast in the Yilan County were formed largely due to tectonic movements in this area. Here it's also

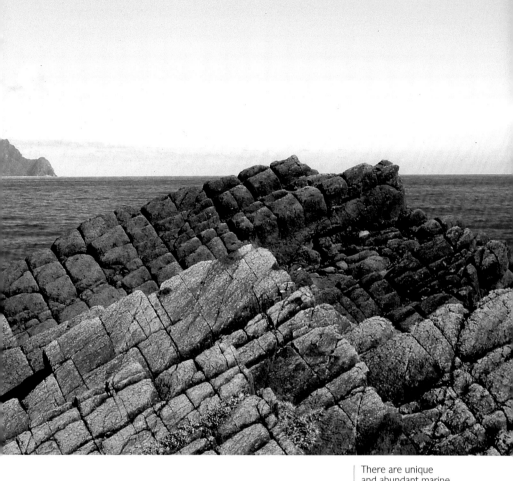

There are unique and abundant marine resources in Yilan.

known for Okinawa Trough's continual expansion, active undersea volcano, as well as the precious Hydrothermal Vent Crab.

Undersea Volcano

The Guishan Island is the only active volcano in Taiwan. Nearby, undersea volcanoes scatter

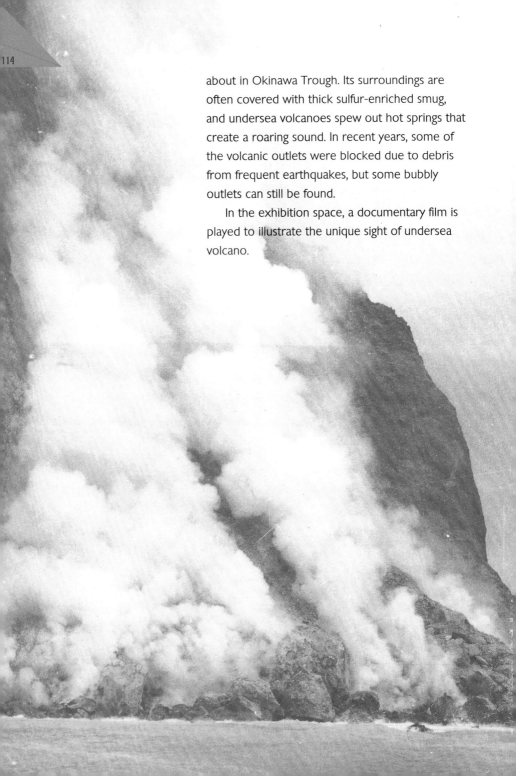

about in Okinawa Trough. Its surroundings are often covered with thick sulfur-enriched smug, and undersea volcanoes spew out hot springs that create a roaring sound. In recent years, some of the volcanic outlets were blocked due to debris from frequent earthquakes, but some bubbly outlets can still be found.

In the exhibition space, a documentary film is played to illustrate the unique sight of undersea volcano.

Hydrothermal Vent Crab

Hydrothermal Vent Crab is one of the few creatures that dwell in hostile environment known for its high temperature and toxicity. When volcano erupts, the instant temperature rise kills the majority of plankton. They move about, rising and descending with the current, like an underwater snow scene. Then comes the good time for Hydrothermal Vent Crab to feed, and that's why they inhabit around the volcanic crater.

Oceanic Crust Movement

1. Continental and oceanic crusts start to move towards and press against each other.

2. When they press harder against each other, the heavy crust will be pushed underneath the lighter one, and the crack forms an oceanic trench.

3. The oceanic crust submerges and melts into lava, which causes the volcano to erupt.

4. Tectonic collision pushes rock beds from deep underneath to the surface that forms high mountains.

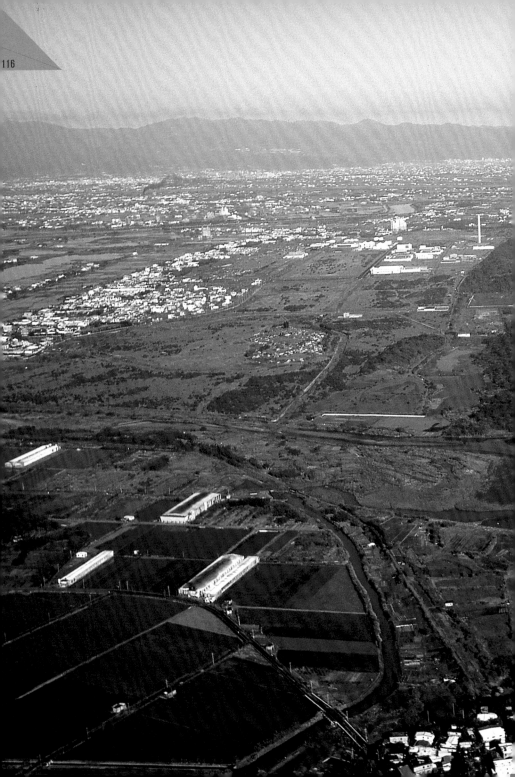

ilan's coastline stretches 101 kilometers and comes in three styles: Jiaoxi fault shoreline, sandy shore from Wai'ao to Beifang'ao, and then Suhua fault coast.

At "Level of the Ocean," tectonic models and large-sized wall paintings present the diverse coastlines of Yilan County. Specimens of creatures unique to this locality are also on display in see-through boxes and flip-through binders for visitors to get a glimpse of the rich ecology.

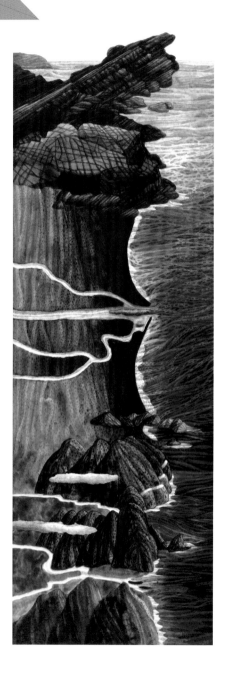

Jiaoxi Fault Coast

To the north of Yilan's coastline is Jiaoxi fault coast. It stretches 21 kilometers and is an extension of the Xue Mountain range. Its northeast-southwest strike coincides with the direction of monsoons and ocean currents, featuring a sea-eroded platform and a uniquely-shaped cuesta. Among many rock cracks hides a broad range of species of the tidal flat.

Sandy Shore on Lanyang Estuary

The alluvial shore is created by the Lanyang River and its tributaries: the Yilan River and the Dongshan River. It stretches from Toucheng Township to Beifang'ao, 36 kilometers in total. The sand dunes along the coastline provide wind and wave blockade. In addition, they also stop the rivers from flowing into the ocean, which forms streams parallel to the sand dunes as a result.

Suhua Fault Coast

Suhua fault shoreline situates in the south of Yilan's coastline. 44 kilometers in total, it stretches from Beifang'ao, Su'ao Township, to Heping River Estuary in Ao Hua Village of Nan'ao Township. The fault coast creates a large height drop; however, still some river deltas were formed, including Tong'ao, Nan'ao

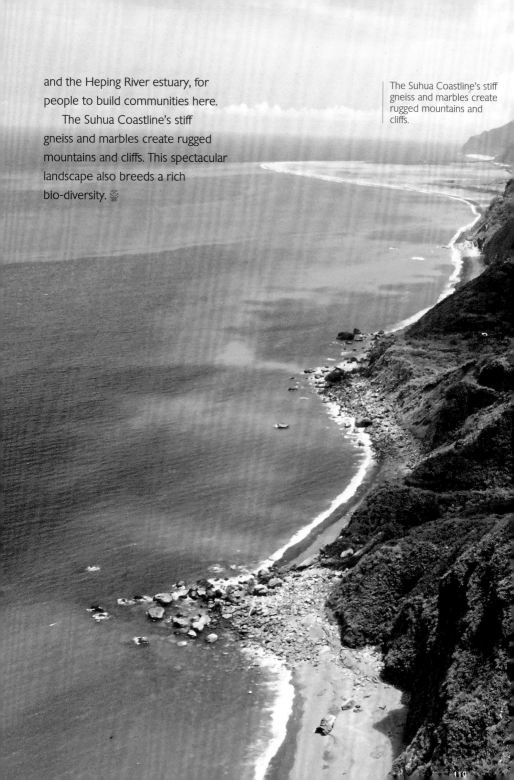

and the Heping River estuary, for people to build communities here.

The Suhua Coastline's stiff gneiss and marbles create rugged mountains and cliffs. This spectacular landscape also breeds a rich bio-diversity. 🌿

The Suhua Coastline's stiff gneiss and marbles create rugged mountains and cliffs.

The Kavalan Tribe's Affinity with Water

Allegedly the Austronesian Kavalan traveled here by sea. They settled among the sand dunes around 10 meters above sea level in the Yilan County. Their early livelihood is based on harvesting, farming, deer hunting and fishing.

Trading Activities

From the excavations of a Kiwulan site, it is found that the Kavalan have called the Lanyang Plain home since more than six hundred years ago. They lived by the water in stilt style houses. Pottery jars with geometric patterns were often used in their daily life.

According to some Dutch literature in the 17th century, the Kavalan were good at sailing and enjoyed prosperous external trading relations. They often sailed between northern and eastern Taiwan for trade, and they also imported various ceramics and jewelry from abroad.

The goods acquired by the Kavalans through trading

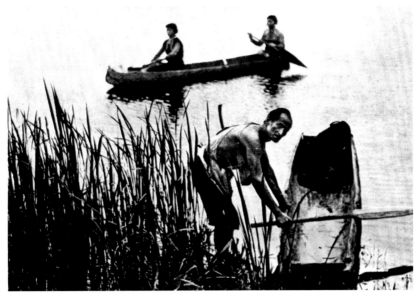

The Kavalan often handled the boat between the northern and eastern Taiwan for business.

Religious Ceremonies and Faith

To the Kavalan, many spirits exist in the supernatural realm, be it gods or spirits of human beings or animals. Many different rituals were performed in hope for continuity of life and peace. It was a unique animism.

When the coral tree blossoms in spring and summer every year, the Kavalan tribes in the Hualien and Taitung County perform a ceremony called "Bar Spaw" on beaches to worship ancestors and God of Ocean, praying that in the flying fish season they would gain a hearty harvest and be blessed with safety when at sea. Shinshe Tribe calls it "Spaw du lazin," and Lide, Dafengfeng and Zhangyuan Tribes call it "Laligi." Albeit the titles differ, they all suggest the same idea of sea worshipping.

The Kavalan is the only tribe reserving the traditional craft "banana fabrics" among Taiwan's aborigines.

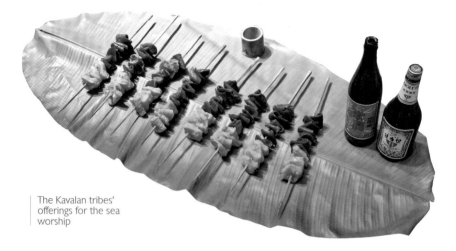

The Kavalan tribes' offerings for the sea worship

Traditionally, sea worship takes place during high tide. Kavalan tribes provide offerings of pig organs, such as heart or liver and pork on a bamboo stick, sprayed with alcohol to make "Spaw." Then the ceremony begins. As fishing is deemed as the duty of men, women are kept at a distance during the ceremony, and widowers and widows are forbidden from taking part in ceremonies, as losing spouses is viewed as taboos and a sign of bad luck.

The Kavalan's traditional faith has been assimilated with the Han's religions after the two sides came into contact. Missionary Dr. Mackay has come to this area and set up churches in many

The house in Wulaokeng
rebuilt by Kavalan in 2005

communities. Some locals were even recruited
for theology studies at Tamshui's Oxford College.
Since mid-19th century, the Kavalan religious
ceremonies have become discontinued in Yilan
area. Currently, these traditional ceremonies
could only be found in Xinshe, Lide, Dafengfeng,
Zhangyuan Tribes in the Hualien and Taitung
Counties.

Water Birds' Paradise

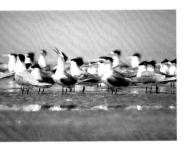

In spring and fall, there are usually groups of migratory birds spotted in nearby coasts.

A black-naped tern perches on a bamboo pole in the wetland. Ducks swim in the water. Cinnamon bitterns, little egrets and herons wander among elephant grass. If you look carefully, you'll even find fiddler crab and ghost crab on the muddy shore in this water bird's paradise.

The Lanyang Estuary

A wetland not only provides an ideal space for environmental education and leisure activities, it is also an important resource for fauna and flora species. Meanwhile, wetland carries important functions of flood prevention and water purification, and in that way provides mankind a safe place to live. The Lanyang Estuary is a world-class wetland and water birds conservation area. This wetland was identified as one of Taiwan's top 12 wetlands by an international organization in 1987.

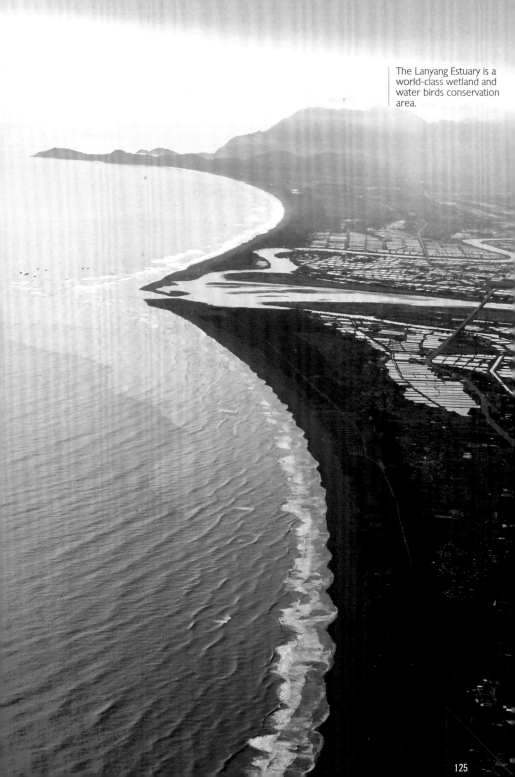

The Lanyang Estuary is a world-class wetland and water birds conservation area.

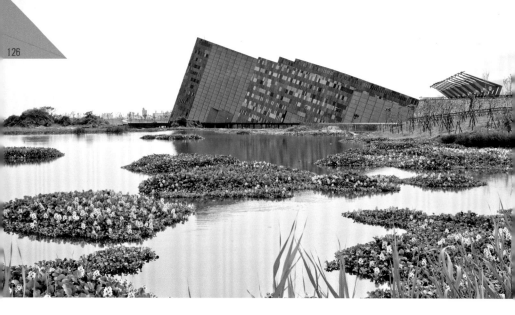

Beauty of Wetland

In the exhibition space, visitors get a chance to witness the rich bio-diversity of the wetland with models of water birds, plants, mudskippers, fiddler crab, and ghost crab.

To enhance visitors' experience and knowledge of the wetland, the museum crafted multi-media content including: "Bird watching through binoculars," which presents the elegant images of water birds; "Computer guides to wetland water birds," giving an overview of unique characteristics, behaviors and habitats of water birds; yet another video clip "Guides to the vanishing folk songs" employing the sounds of bird tweets and slang to show how locals dialogue with the nature. The big screen repeats images of wetlands around Yilan County, including areas like the Wuwei Port, 52 Jia, the Lanyang Estuary, the Zhu'an Estuary, and the Wushi Port, where the museum situates.

The Lanyang Wetland is a fertile river delta that consists of mud and organic matters washed down from upstream.

This wetland contains a mixture of different

landscapes: sandy shore, coastal forests, muddy shore, swamp, sandbank, river and dry field. The fertile land provides ample food for fish, shrimp, shell fish and crab, as well as ground for reed and sea grass to grow, which in turn attracts birds to take shelter and to forage here.

In spring and summer, large numbers of egrets flock here to nest. Among them, one kind of large-sized migratory bird, heron, often cautiously stand motionlessly in the water to catch the fish that swims by them. Farmers call them "the birds that stand still."

Every year between winter and spring, ducks and geese are often spotted here as well. There are green-winged teal, northern pintail, and spot-billed duck, among which green-winged teal accounts for the majority. Male ducks are known for their bright-colored feather, maroon head, and green rim around the eyes. The locals call them "the Golden-winged." Female ducks, rather on the plain side, have only dark brown feathers.

Wide open sand bank, tidal flat, swamps and nearby fallow farm land by the estuary are home to snipes and plovers, which feed on lobworm, crab and other small-sized invertebrates. The bird's number is well above thousands. Some just pass by and some may spend the winter here. From September to May next year is the best time to watch these birds. During the summer time, the river delta is an ideal place for Chinese crested terns, little terns, and black-naped terns to come search for food and a resting spot. 🎋

The Lanyang Estuary is the paradise of water birds.

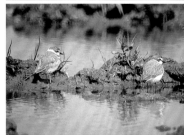

Fish Swarms

The waters near Yilan area are famous for mackerel fisheries. On the food chain, mackerels are often eaten by larger carnivorous fish. To continue their species, each mackerel is able to bear over thousands of fish, which also gives life to the economy of the fishing villages along Yilan's coast.

Visitors can gain a good understanding of the fish resources through the fish models, including sail fish, mackerel, flying fish, jackfish, dolphin fish, and large headed ribbon fish. The fish would leap up according to the names called, along with the caption "one for round snout, two for red shark, three for butterfish, four for Japanese-Spanish mackerel, five for croaker, and six for snapper," and "got money then eat croakers, no money then eat nothing."

Spear Fishing

The Nanfeng No. 1 is the largest display in the Lanyang Museum. It is a rarely seen wooden boat that once witnessed the roaring waters and the fisheries in Nanfang'ao.

When catching sailfish, the Nanfeng No. 1 would first set up a spear rack. The main spear rack controller is in charge of aiming, while the supplement controller helps with directions, and sometimes would take the main controller's place. The marine engineer chief steers, while the crew at the back would put down the rope and keep watching on the fish swarms, while processing the sailfish captured.

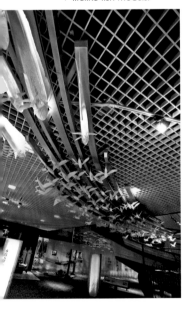

Visitors can gain a good understanding of the abundance of fish resources through the lifelike fish models.

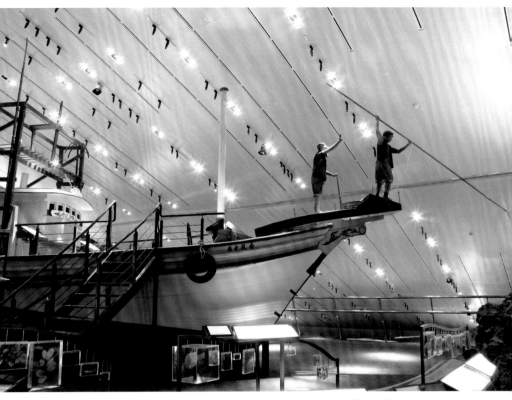

The Nanfeng No. 1 is the largest display in the Lanyang Museum.

What the fishermen would call "mini trident" is made of spear rod, iron fork, spearhead, and spear rope. Another type of single spear stick is also available onboard, used to catch a larger species.

The sailfish fishing scene is now presented in the museum, featuring models of Captain Lin Ah-huang and his crew from the ship Hsindefa. Tools and various objects, such as anchors, ropes, spears, fishing equipment, and cooking ware are presented to exhibit the fishing process.

A documentary of how fishermen catch the fish is shown by the boat.

The Largest Display - Nanfeng No. 1

Built in 1980s, the Nanfeng No. 1 changed several owners as well as its names. The last owner was Mr. Zhuang Jin-jung, who was born to a fisherman family and began fishing as early as age 17. In 1983, he purchased Nanfeng No. 1 with his older brother and began a brand new journey.

After the fishery industry withered, he turned Nanfeng No. 1 into an ocean hotel. In 2002, when Nan An Junior High School established a fishing history display hall, he generously donated the ship, which was renamed Nanfeng No. 1 by the school principal. In 2005, the school donated the ship to the Lanyang Museum for educational purpose.

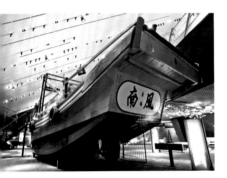

| Nanfeng No. 1

The Structure of Nanfeng No. 1

The Nanfeng No. 1 can be divided into three major sections: fish cabin, stock cabin, and sleeping cabin. The most spacious area is reserved as fish cabin, while the head and the tail are used for sleep and stock to balance the weight. The bottom of the ship is made of red cypress.

The refrigerator is used to store the catch. The amount of ice to carry is based on the intended days for the journey and the distance of the destination. Generally, ten large ice cubes, each weighing 200 kilos, are carried onboard during each trip. The refrigerator stores both the catch and the food for the crew.

The sleeping cabin is where the crews rest. It contains simple bedding, clothing, cupboards, and food storage. Crews mostly sleep with their heads toward the ship tail. The weight in the refrigerator would cause the head of the ship lower and the tail upper. Sleeping with the head in direction of the upper end is a more comfortable position.

Diou-Zou-A

Aside from spear-fishing, popular fishing methods include long line fishing (a method to put down a rope behind the boat to catch larger fish) and a local method known as Diou-Zou-A, conducted by a mother boat that carries ten to twenty rafts. Once reaching the fishery, the rafts are put on water while the fisherman yanks a rope to attract fish. This approach is rarely used today.

The tail of Nanfeng No. 1 is designed for long line fishing, while the bamboo raft on the side was used for Diou-Zou-A. The raft was specially remade by the local elderly when Nanfang'ao Fishing Culture Association held an event to promote traditions. The raft was later donated to the museum.

Shellflower Rope

In 1940s, before iron anchors and chains were used to stop a ship, fishermen mostly relied on shellflower ropes to tie the boats. The women in fishing villages would collect shellflowers to dry and chop, and then extract the fibers to form threads. Hundreds of shellflower ropes would make a large rope to help park a boat. The shellflower ropes

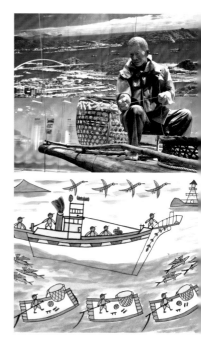

Diou-Zou-A is one of the popular fishing methods in Yilian.

Fishing Tools A bright light is generally used to attract fish during fishing amid the fish's phototropism. The hanging light onboard for this purpose is called a "fish-gathering lamp." Lighting used in water for the same purpose is called "underwater lamp." Other commonly used fishing tools include hooks, float, cage, and needle.

The ropes made by shellflower's stems were used to stop a ship previously.

were also made into fishnets that were left in fixed spots in ocean to catch fish, which was known as "fixed fishing."

The rope-making tool is displayed here: a frontal cart contains handles and turning knobs. The cart must be fixated on the ground. Three turning knobs are attached to a beam. When making a shellflower rope of three strands, three people are required to turn all three knobs. If only two strands are required to make a rope, then only two knobs need to be turned.

The picture shown at the back is the back cart, also known as the triangular rack. There is only one turning knob on the handle board. The back of the triangular rack is a supporting frame, where sandbags are piled to prevent tipping when the rack turns to make a rope. Two long wooden sticks are placed below the rack as the track for the triangular rack, which would move when the rope is spun during making. The ram-looking device is the three-strand weaver, which as suggested by the name, can spin three strands into a thick rope.

Yakitama Internal Combustion Engine

The museum has a Yakitama internal combustion engine taken from the ship "Yongyufeng." The engine is the heart of a ship, and this set is manufactured by Su'ao Iron Plant. It is modified based on a Japanese model, and has 30 horsepower.

By 1990s, the distant-water trawlers would operate on four cylinders and five hundred horsepower. These ships were also produced by local factories in Yilan. Plants in Su'ao, Nanning, and Xisheng could produce up to four duo-cylinders and eight Yakitama internal combustion engines each month, which were proudly sold to Japan and Southeastern Asia.

Yakitama internal combustion engine operated on heavy oil and would make loud sounds when working. When the ship sailed away at 2 am in the morning, the engine sounds would be heard by all homes, making it a special memory for residents of Nanfang'ao.

The shellflower rope would begin to rot after three to four months in water. When iron anchors and chains became available in 1960s, boats began to use them to anchor.

Industries in the Fishing Port

Each boat needs a port to park. Over ten fishing ports exist along Yilan's coast, such as Daxi, Gengfang, and Nanfang'ao, all renowned for the fresh catch. Cultures develop with fishing activities as fishermen gather to form villages.

The growth of fishing industry gave birth to peripheral businesses, such as shipbuilding plants, fishing tool and ship part manufactures, iron plants, and ice-making plants. Fish processing industry began to rise, as did transportation, which prospered tourism.

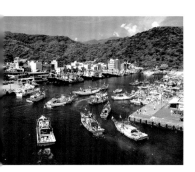

The momentum on fishing industry drove up the development of periphery industries, forming a unique culture of fishing villages.

Fish Auctioneer

Fishery catch auctioning is an interesting trading method that involves an auctioneer to shout out the price and buyers who make bid offering. The site is generally filled with bustles and noises, as well as tension in the air.

The First Fish Market in Nanfang'ao mainly sells large catches like tuna, shark, sailfish, and dolphin fish. The selling generally begins at 3 or 4 am to ensure fresh catches are sold as quickly as possible.

The Third Fish Market mostly sells frozen catches of distant-waters. Buyers come on board to select their purchase. The entire stock is then loaded on a truck to be delivered to a processing plant.

The Second Fish Market and Daxi Fish Market sell fresh fish caught by smaller ships from nearby waters. This is known as "spot catch." The trading generally takes place between 3 and 5 pm. Auctioneers would cry out prices, while onlookers, or locals, could bid and purchase small amounts. The fish auctioning has become a favorite activity for visitors.

The busiest activity at fishing port is the auction. The large-scale trading usually begins three or four in the morning. An auctioneer shouts out a price on batches of fresh catch, while onlookers bid. The atmosphere gets nervous as prices change. A footage on fish auction is played to bring the excitement to display.

The Fisherman's Emotions

The charm of the sea is mesmerizing; it may bring abundance, but may also bring dangers with its roaring tides. It is not hard to imagine how the families feel as they wait by the sea for their beloved ones to return.

Through the images on display, the spirits of the fishermen, the glory, the hardship, the panics of families, and the toughness are presented in the most touching way. 🌸

The Mazu Religion

Goddess Mazu is a guardian for fishermen and provides refuge for the weary hearts. Her statue is generally kept in the upper deck on a boat. When swarms of fish are discovered, the crew would first burn incense to express gratitude before starting catch.

On March 23 on lunar calendar every year, Nanfang'ao Nantien Temple, which worships gold Mazu and jade Mazu, and Jinan Temple, the earliest to worship Meizhou Mazu, would hold the large "Mazu Welcoming" event to celebrate the goddess's birthday. It is a major event for the village. Each household would burn incense for offering and kneel before her. During the ocean procession, all Mazu statues from various temples and other god statues would be gathered onboard of over one hundred boats, which would sail around the Guishan Island and the Pengjia Islet. The waters would be filled with boats, forming a magnificent view.

Impressions of Lanyang

The Guishan Island
Every time when Lanyang's children leave home by a train
Staring at you from the window
It is never possible to tell if the sadness in the air
Belongs to you or them.

The Guishan Island
When Lanyang's children spend their days away from home
Dreaming are the reason making their nights sleepless
They would dream of the Zhuoshui River
Typhoons Pamela and Bess
They would dream of you, the Guishan Island
Doctors would teach them to count sheep
One sheep, two sheep, three sheep
Four Zhoshuei Rivers
Five typhoons
Six Guishan Islands.

The Guishan Island
Every time when Lanyang's children come home by a train
Staring at you from the window,
It is never possible to tell if the happiness in the air
Belongs to you or them.

Huang Chun-ming "Guishan Island"

Touching Moments

Following the visits of the Mountains, the Plains and the Ocean Levels, which make visitors immerse in the ecological knowledge and the culture, we expect them to further transfer the

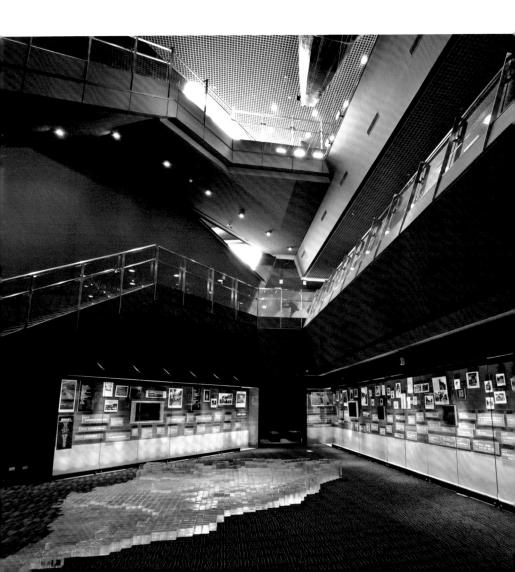

knowledgeable feelings to the touchiness and recognition to Yilan.

The touching moments would not end at the museum exit. Photography images from different eras display histories and stories in Yilan at an atmosphere of reminiscence, taking visitors into another level of thoughts, while transforming the inspiration into the visions of Lanyang.

This Time Gallery exhibits the human side of Yilan through old photos.

Reminiscence at the Time Gallery

The Time Gallery exhibits glimpses of Yilan taken from different eras through old photo images, poetry, and writings. Photography of selected Yilan-themed artworks would also found here.

Unlike the general chronological chart, the timeline on the wall mostly uses images accompanied by brief descriptions to display the periods of prehistory, the Qing Dynasty, Japan's colonization, and the Post War. Together with the broadcasting of documentary films, impressions of Yilan County is portrayed via views of locals and litterateurs, as well as the art, culture, industries, and lifestyles.

Last but not the least, take a step into the video room and see how the Lanyang Museum was born.

Bedazzled by Light of Yilan

"Light of Yilan" is an installation artwork combining mosaic with lighting effects. Built as 1/1000th scale of Yilan area, a 3D map is artistically constructed with over 2,000 acrylic poles. Below these poles lie hundreds of images of the Lanyang

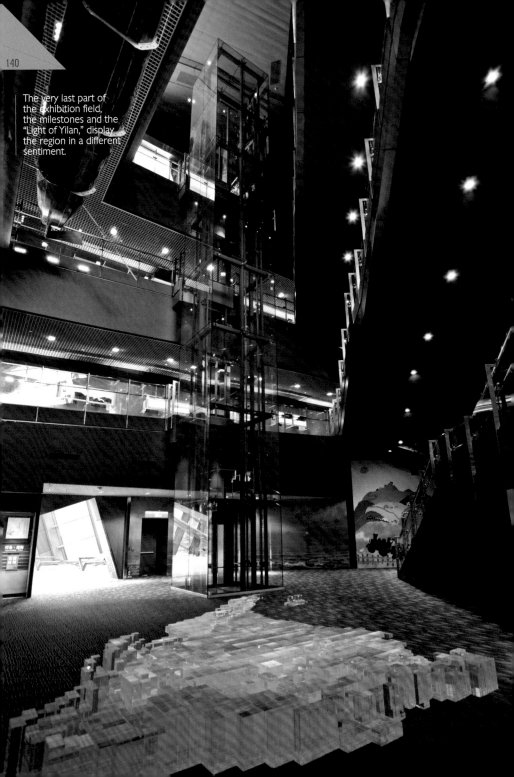

The very last part of
the exhibition field,
the milestones and the
"Light of Yilan," display
the region in a different
sentiment.

The "Light of Yilan" makes a perfect ending for the exhibition.

area from all seasons; with a palette of colored lighting mixtures, from blue, orange, green, purple, to originals, the Lanyang ground is shaded with different hues and extraordinary looks.

The most special thing is that "Light of Yilan" will be updated with new content. In the future, there will be events to call for stories and images with specific themes that take place in Yilan. As time goes on and the land changes its scenery, the harmony will continue to flow on the land of Lanyang. 🌺

Behind
the Scenes

The arduous journey has finally come to a fruitful bearing, thanks to the selfless devotions from each team member. Now, the Lanyang Museum is complete with vivid models mimicking real life objects, fantastic films, images, texts, and inspirational devices, ready to tell Yilan's touching stories.

Passion Paves Way for the Lanyang Museum

Thanks to the devotions and efforts from countless individuals, the Lanyang Museum finally began its trial operation on May 18, 2010, the International Museum Day.

The funding of the museum was half subsidized by Council for Cultural Affairs and half supplemented by the county government. The project was divided into different parts according to the specialty of each county government team: the building and construction section was assigned to handle landscape design and construction, the land office and the Lanyang Museum jointly managed the land obtainment, and the Lanyang Museum directed the exhibition and operation.

When Artech Inc was commissioned to design the permanent exhibition of the museum, the architects took inspirations from nature and developed a "mountain-plain-ocean" structure for the interior, developing the subject "ecology-human-coexistence" along this idea. Exhibition rooms, interconnected in a step-like descending order, echo with both the themes of each floor and the Yilan's unique geography.

The non-architectural parts were collaborated by various professional teams, including the famous 3D Concepts from UK, who were invited to help during the basic design stage, and Chiguan

The big window allows the tourists to appreciate beauty of the wetland.

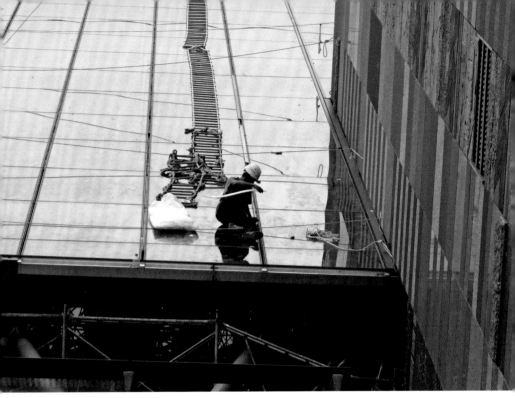

The construction process of the main engineering project was quite laborious, complicated and difficult.

International Exhibition Planning, a renowned local firm that continued the latter works. Due to the in-depth data collection, wide discussions, and careful examination works, the duration of the planning stage eventually was much longer than anticipated.

Difficulty in Making the Exhibitions

While the framework of the museum building was collaborated by the architects, consultants, constructors, and all participating individuals, the interior of the facilities and exhibition planning was a challenging task that was divided into five parts: image and text integration, culture and ecology filming, landscape and display model

The left was the construction of the landscape architecture; the right was that of the exhibition.

production, audio visual systems, and computerized museum guidance. The commissioning work and subcontractor selection began in 2005.

To achieve strict quality control, the construction of each part adhered to different steps of production and inspection guidelines: film completion included scripts, footage, narration, and music; display model-making process began with drafts, and then proceeded to prototype, finishing, and coloring; audio visual facilities involved complicated specification and parameter matching; the installation followed public construction rules with precision.

All of these involved meticulous efforts and vast commitments from professionals of each field, scholars, history workers, and local elderly. The participating staff also gained valuable expert learning during the process.

In order to recruit top quality professionals of each field and avoid budget related corruptions from all-in-one contract issuance, our team decided to split up projects based on subcontractor expertise and construction nature. Although detailed working complicated the administration

process and integration, while bringing more workload on staff, the process was inevitable to ensure the best.

The most difficult task was the content research. Since the exhibition covers nature, ecology, culture, history and much more, every image, quote, human posture, clothing, color hue of animals and plants, and texture must undergo careful discussions and consultations before selection.

The integration with various items was an even more challenging task that involved clarification between working steps and conflict resolutions among subcontractors of the same tier. The constant adjustment was required to bring together each production. We received support and warmth with gratitude while dealing with these challenges, especially when each participating individual took patience to answer endless questions from us. Green Country Industrial Co., Ltd, the contractor for model production, raised their own ducklings to ensure the accurate color of the feathers for their works; Liu Guang Chuang, a film production company, took three years to complete the portrayal of the Grappling with the Ghosts ceremony in Toucheng.

This arduous journey has finally come to a fruitful bearing, thanks to the selfless devotions from the inspection committee, consultants, subcontractors, and each team member. Now, the Lanyang Museum is complete with vivid models mimicking real life objects, fantastic films, images, texts, and inspirational devices, ready to tell Yilan's touching stories to everyone. 🌸

The model in the exhibition area

The Emblem

The name of Yilan originated from the Kavalan. Over the centuries, the Pingpu Tribe lived here, beginning working in the dawn and taking a break until the sunset, forming the basis for the multi-cultures on this land.

During the initial design process of the emblem, a group of museologists, historical and cultural scholars, ecologists, local artists, and corporate identity system (CIS) designers discussed and agreed on the adoption of the wood-carved human figure, a totem commonly seen in the traditional Kavalan woodworks. It has been a cultural symbol deeply-rooted in Yilan's culture, and is now a token for the interactions of man, environment, and the museum.

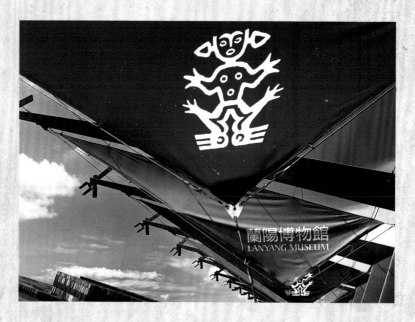

In 1999, the Lanyang Museum conducted the first-stage color planning, with the selected clover green as the base tone to portray the boundless farmlands in the Lanyang Plain. Together with the Kavalan's human totem, the patchwork-like rice paddies on the plain represent the museum's image of endlessness and fruitfulness.

After years of planning, the museum was finally opened in 2010 in the Wushi Port, with the building's framework incorporating the landform of the northeast coast, the "Cuesta," which has a blue-gray tone like elegant and magnificent ocean. The second-stage emblem CIS color design was adjusted to echo the building, giving the museum a harmonized visual impression reflecting the nature.

To fully exploit the use of totems, we added a Kavalan face that incorporates diamond-shaped patterns seen in folk weavings. By introducing these details, we hope to bring the public unique cultures that can only be found in the Kavalan tribe.

Major Events

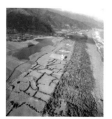

Date/Year	Major Event
1989	Local residents first proposed the building of "Kai-lan Museum."
February, 1991	Lien Zhan, the former provincial chairman of Taiwan, commissioned Department of Education to assist the establishment of the Museum.
December, 1992	Yilan County Government established a museum planning committee, and decided the museum's name "the Lanyang Museum" located in the area of Wushi Port.
September 16, 1994	Under the commission of Yilan County Government, a joint implementation team was formed by National Museum of Natural Science and Building and Planning Research Foundation, National Taiwan University to carry out "the Lanyang Museum Implementation and Design Plan." The plan was completed in June, 1995.
January, 1996	The National Museum of Natural Science and Building and Planning Research Foundation, National Taiwan University received further commission to carry out "the Lanyang Museum Implementation and Design Plan."
March 19, 1999	The Executive Yuan officially budgeted aids and confirmed the intended sponsored fund ratio for the building (50%).
March 20, 1999	The Lanyang Museum Preparatory Office established with mission-specific teams.
April 22, 2000	Artech Inc was awarded the design and construction rights of the Lanyang Museum.
August, 2000	The Yilan County Government announced its city plan to expropriate the proposed museum and obtain the ownership section by section.
January, 2001	The Yilan Wild Bird Association was commissioned to conduct a wild bird eco-environment research for the proposed Lanyang Museum site, the peripheral area, and the Yilan coastal wetland. The task was completed in April during the same year.

Date/Year	Major Event
January 4, 2001	The first issue of the *Lanyang Museum Journal* launched, and was later reissued as e-Zines in July, 2006.
June, 2001	Artech Inc completed the Lanyang Museum building planning and reporting.
October 5, 2001	1924 artifacts belonging to the Art & Museum Section, as well as Department of Cultural Affairs and Yilan County, were examined and handed over to the Lanyang Museum.
May, 2002	Artech Inc was appointed to carry out the planning, finalize the detailed design and implement it.
June, 2002	The area of the proposed museum site was officially rezoned for public educational use under urban planning. The expropriation process of the land was completed by July, 2003.
January 17, 2003	A collection donation ceremony of Wangye Boat, Bo'a Boat, tricycle and many more items were held in the lobby of Yilan County Department of Cultural Affairs.
February 14, 2003	Received Su'ao-made internal combustion engines taken from Yongyufeng Ship and Xinchuanfu 216 Ship.
July 3, 2003	Artifacts from the Mansion of Huang, a successful candidate of the imperial exam, were donated to the Center of Traditional Arts.
July 13, 2003	The 12th Presidential Hall Regional Cultural Exhibition-Yilan County was held to host various activities relating to Yilan County.
December, 2003	The completion of detailed design plans and budgeting.
2004	The museum officially became the second-level administrative organization of Yilan County Government. The organization's structure consists of a director, a secretary, and three sections: Research and Collection, Exhibition and Education, and Administration. The employees were comprised of government staff and educational staff.

Date/Year	Major Event
July 17, 2004	A pre-construction opening event "Museum Conglomeration: Tour of the Museum" was held in Jiuqiong City (Yilan City).
July 31, 2004	The construction commencement ceremony of the Lanyang Museum was held in Wushi Port.
August 2, 2004	The construction officially began.
December 8, 2004	The House of Yeh I-hsing was almost torn down by the owner. The museum came into rescue and collected important items of the lobby.
December 16, 2004	Yeh Shun-deh and 13 members of the House of Yeh I-hsing, donated 87 pieces of furniture to the Museum, including an 8-legged bed.
June, 2005	Detailed management plan research and draft was launched, and completed in December in the following year.
July 14, 2005	Nanfeng No. 1, a harpoon fishing vessel was donated to the Museum by Nan An Junior High School in Su'ao Township.
August 23, 2005	Financially troubled Tian Yi Constructions discontinued all projects works without announcement. The County Government terminated the contracted on October 13, 2005.
January 11, 2006	Stage one landscape tendering process completed in November, 2006.
October 4, 2006	The New Building tendering (a connective construction) process began, and was won by Lijin Engineering Co., Ltd. The construction began on October 28.
November 29, 2006	The New Building tendering (machinery and electrical engineering) began, and was won by Jiajia Utility Company.
August 15, 2007	Fishing vessel Nanfeng No. 1 and a Yakitama internal combustion engine were hoisted to the second floor of the Lanyang Museum.
November 13, 2007	Mr. Chen Zhi-an, the county public construction bureau executive, died during duty.
April 2, 2008	A completion ceremony was held for the Museum's main building.

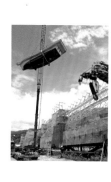

Date/Year	Major Event
June 16, 2008	Chi Yi Constructions Co., Ltd received the contract for museum's main body repair and installation, machinery and electricity engineering, and board integration.
August 25, 2008	Shun Ying Constructions received the contract for stage two landscape construction, including the plaza, around-the-site walkway, and plantation.
May 13, 2009	Land lot number 95-1 and 95-2 (of Gangkou Subsection, Gangao Section, Toucheng Port, Yilan County) was transferred to the museum, for management.
August 28, 2009	The first Lanyang Museum volunteer recruitment.
March 25, 2010	Museum office officially opened for staff.
May 18, 2010	The Museum began Stage 1 trial operation on this date, the International Museum Day, only group visits with advance reservations were accepted.
June 25, 2010	Stage 2 trial operation began with the opening of "Beauty of the Handmade Craft- Yilan Living Art Exhibition," when the museum became fully-opened to the public.
July 9, 2010	Batches of collection pieces arrived at the Museum.
August 30, 2010	The Lanyang Museum won the 7th Far Eastern Architecture Design Award–Taiwan Region Outstanding Award, the highest honor of the architectural circle of Taiwan.
October 16, 2010	Grand opening of the Museum. Mr. Zhuang Jien-hsu donated pottery works from early days of Taiwan.
October 27, 2010	The museum won the First Prize of 2010 Taiwan Architectural Award.
December 3, 2010	A special exhibition "Exploration of Kiwulan" opened.
December 4, 2010	An evening banquet themed "The Night We Return" was held to express gratitude to all the people who had contributed to the construction process.
December 7, 2010	The Museum won the 10th Public Construction Golden Quality Award.
October 31, 2011	The Museum won the International Awards for Liveable Communities–Project Awards–Built.

To be continued…

Visitation Guide

Map of Museum Exhibition Venues

 The Mountains

The woods in Yilan are often described as Misty Forests to reflect the rainy climate and mountain landforms. The moist Siyuan Saddle nurtures various types of species. From large Taiwan cypress trees, beeches, an ice age relic found on ridgeline, Sassafras randaiense, broad-tailed swallowtail butterflies, to mountain lakes, the Mountains Level comprises a rich variety of creatures in Yilan.

 The Ocean

Hundreds of streams on the Lanyang Plain merge before entering the ocean, where the water blends with Kuroshio, tides that move northwardly from the equator. Feel the movement of the waves and the roars of undersea volcanoes here amongst the swimming eel fry and swaying corals.

 Time Gallery

This level exhibits the human side of Yilan through literary works, old photos and films, exquisitely transforming the history and facts into touching moments that only belong to Yilan.

 ◀ To the platform of wetland landscape

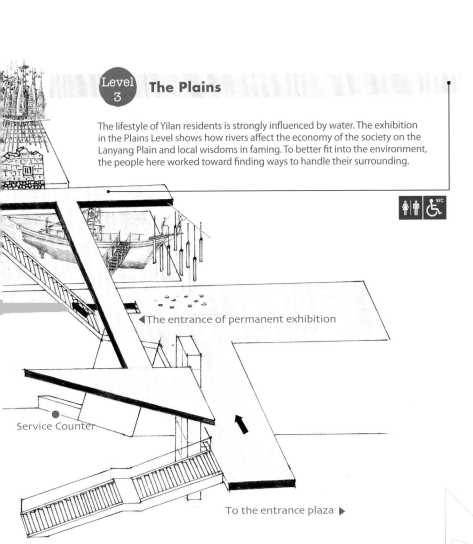

Level 3 The Plains

The lifestyle of Yilan residents is strongly influenced by water. The exhibition in the Plains Level shows how rivers affect the economy of the society on the Lanyang Plain and local wisdoms in faming. To better fit into the environment, the people here worked toward finding ways to handle their surrounding.

◄The entrance of permanent exhibition

Service Counter

To the entrance plaza ▶

The Layout of Lanyang Museum

The Museum's Architecture Profile

Building Area: 7681.72 square meters

Park's Area: 10.9 hectares (including 4.47 hectares wetland)

Overall Floor Area: 12639.4 square meters

Exhibition Area: 5417.47 square meters

Height: 31.15 meters

Number of Floor: four

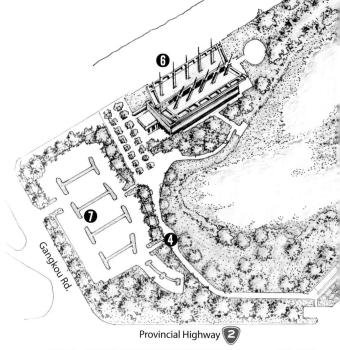

❶ Lanyang Museum

❷ Entrance Plaza

❸ Turtle-watching from Wushi

❹ Sails at Wushi in Spring

❺ Historic Wushi Port Site

❻ Wushi Port Tourist Center

❼ Visitor Parking Lot

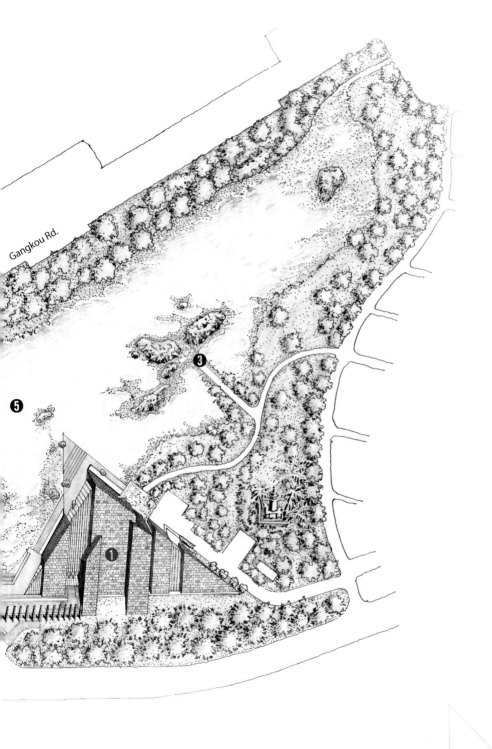

Gangkou Rd.

Information

 Transportation

Driving

Route 1: Drive southwardly along Provincial Highway No. 2 from Keelung. The Lanyang Museum is located on the 134.5th km just beyond Beiguan.

Route 2: Drive along National Freeway No. 5 and get off at Toucheng Exit in the direction to Toucheng and the Wushi Port. The museum is right on the 134.5th km on Provincial Highway No. 2.

Public Transportation

Train: Take the Eastern Line and get off at the Toucheng Station. The museum is 20 minutes away on foot along the Wushi Port direction.

Bus: Take a bus passing through the National Freeway No. 5 to Jiaoxi, and take a Kuo-Kuang Bus to the Wushi Port Stop.

 Museum Hours

9:00~17:00 from Tuesday to Sunday and public holidays (ticketing service closes at 16:30) The museum closes on Mondays and specified dates announced.

 Price

Adult: $100
Group: $80 (of 30+ persons)
Student: $50 for children aged 6~12 and students (ID required)
Concession: $30 for student groups (30+ persons) and Yilan county residents (ID required)
Free Admission: Visitors with disabilities plus 1 companion, children under 6 years of age or below 115cm of height, and seniors over 65 years of age. ID must be presented to show the eligibility for free admission and discounted tickets.

 Guide Service

Audio Guide: Free audio guides on the 1st floor, available in Chinese, English, and Japanese, with the duration of 1.5 hours. ID required.

Group Tour: See museum announcements.

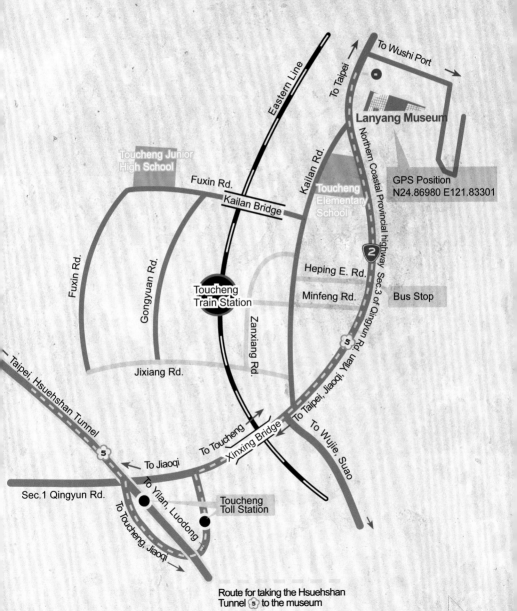

N

To Wushi Port

To Taipei

Eastern Line

Kailan Rd.

Lanyang Museum

Toucheng Junior High School

Northern Coastal Provincial highway Sec.3 of Qingyun Rd.

Fuxin Rd.

Kailan Bridge

Kailan Rd.

Toucheng Elementary School

GPS Position
N24.86980 E121.83301

Fuxin Rd.

Gongyuan Rd.

Heping E. Rd.

Minfeng Rd.

Bus Stop

Toucheng Train Station

Zanxiang Rd.

Jixiang Rd.

Taipei, Hsuehshan Tunnel

To Toucheng

Xinxing Bridge

To Taipei, Jiaoqi, Yilan

To Wujie, Suao

5

To Jiaoqi

Sec.1 Qingyun Rd.

To Yilan, Luodong

Toucheng Toll Station

To Toucheng, Jiaoqi

Route for taking the Hsuehshan Tunnel ⑤ to the museum

Publisher : Lanyang Museum, Yilan County
Issuer : Liao Jen-i
Editorial Board Members: Tsou Ping-wei, Chiu Hsiu-lan, Chang Cheng-feng, Liao Ying-jie, Lin Hong-ren, Hsu Hao-lun
English Referee Members: Chen Tsang-to, Wang Weng
Executive: Business Weekly Editing Co., Ltd.
Executive Editor: Chan Yu-wen
Address: No. 750, Sec. 3, Qingyun Rd., Toucheng Township, Yilan County 26144, Taiwan
Website: www.lym.gov.tw
Telephone: +886 3 9779700
Fax: +886 3 9779300
Image Sources:
Li Sheng-zhang(cover)
Lin Ming-jen(P.4~5, P.7, P.29, P.48, P.56~57, P.61, P.72~73, P.75, P.76, P.78, P.92~93, P.106~107, P.112~113, P.116~117)
Institute of Yilan County History(P.6, P.13, P.68, P.70, P.71«photo by Lai Chun-baio», P.85, P.88, P.94, P.97, P.104, P.114)
History of Kavalan County(P.8 top, P.69, P.85 background)
Poetry of Yilan(P.8 bottom, P.96)
Yilan Museums Association(P.10~11)
Lin Rui-quan(P.14~15, P.28, P.33, back cover)
Artech INC(P.16~17, P.49, P.153)
Qiu Xian-zhu(P.18)
Lai Chun-baio(P.24, P.119, P.125)
Liao Gang-sheng(P.26)
Lin Yu-de(P.31)
Lin You-nong(P.32)
Liu Han-shen(P.42)
Lu Yu-yuan(P.101 background)
Deng Zun-ren(P.50~51)
Lin Shu-tzong(P.62)
Lin Chia-hung(P.63 right & left bottom)
Lee Hui-yung(P.63 left top three, P.121)
Zhen Jian-zhi(P.65)
Woolin Publishing Co., Ltd.(P.66, P.67 3~5)
Illustrated Handbook of Lanyang Historical Heritage(P.83)
Lin Cheng-fang(P.89~90)
Hsu Hao-lun(P.47, P.91 left bottom)
Chiu Chin-yi(P.100, P.105 top)
Li Kun-zhong(P.102)
Chuang Ya-hui(P.103)
Zhang Liang-ze(P.121 top)
Chiu Hsiu-lan(P.121, P.123)
Wu Yung-hwa(P.124, P.127)
Jian Yu-yi(P.132)
Huang Chun-ming(P.136~137)
Shi Ming-cheng(P.142~143)
Zheng Jin-ming(P.150)
Publish Date: 2012.02